CHURCHES OF BUCKINGHAMSHIRE

EDDIE BRAZIL

AMBERLEY

This edition first published 2024

Amberley Publishing
The Hill, Stroud
Gloucestershire GL5 4EP

www.amberley-books.com

Copyright © Eddie Brazil, 2024

British Library Cataloguing in Publication Data.
A catalogue record for this book is available from the British Library.

ISBN 978 1 3981 1138 7 (print)
ISBN 978 1 3981 1139 4 (ebook)

Typesetting by SJmagic DESIGN SERVICES, India.
Printed in Great Britain.

CONTENTS

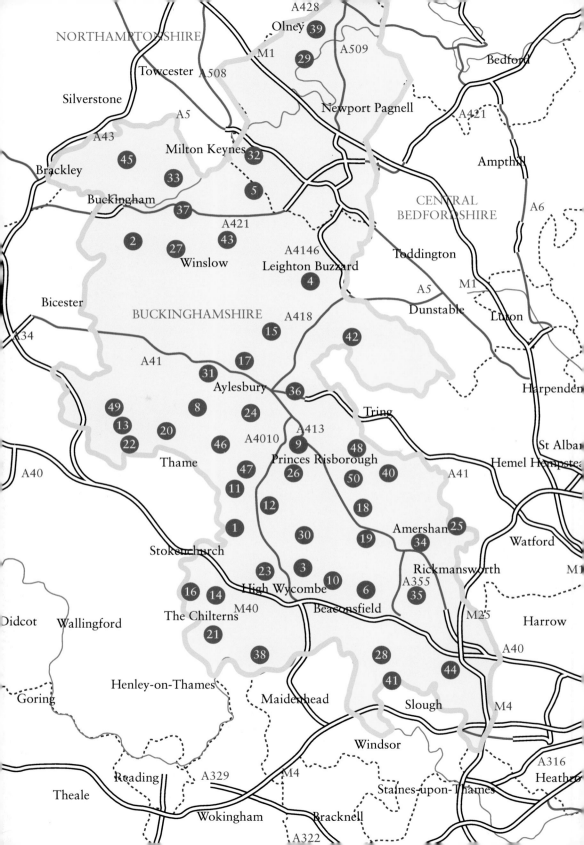

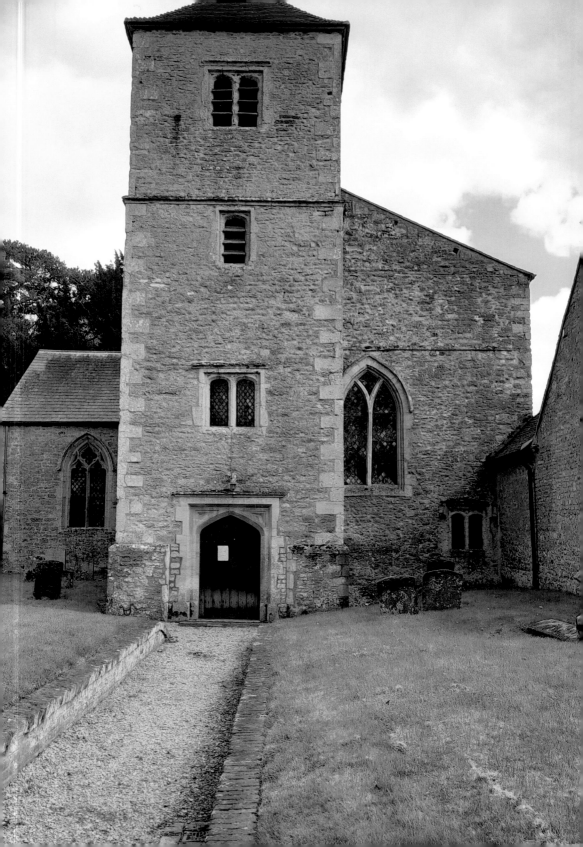

INTRODUCTION

There are roughly around 200 parish churches in Buckinghamshire. Together with the many other hundreds dotted around the country they collectively represent over a thousand years of continual Christian worship. Some are grand, some small, others tall, squat, ancient and modern. Yet, all today still fulfil the purpose for which they were established and constructed: the teaching, celebration and administering of the Christian faith. But this is not a book solely about religion. It is also about church architecture and its changing fashions and styles. It is about the liturgical, social, and religious advancement and upheavals of the church throughout its life. It is about the history of England, its kings, queens, gentry, people, conflicts and politics. It is the sum of all these things which down the centuries have combined to shape and mould the churches we see today, and help tell their own unique stories.

However, during the research and writing of this book, I often heard the words, 'When you've seen one church you've seen them all.' It is a phrase which continually irritated and frustrated me, for it is so erroneous that it is tantamount to a falsehood. As one might expect such sentiments are held by people who have no interest in church architecture, or history for that matter. Yet, to be fair to these disinterested parties they are correct in one way. As we rush and stumble our way through the working day, we probably glance over at the soon-to-be-passed church. As usual, there is the tower. Then there is the large part in the middle, the nave. At the other end there is the small part, the chancel. And in between are the usual pointy windows. And they are perfectly right. For it is those three combined elements of construction which make up most of our parish churches. The trouble is that many people look, but they never see. For if only our disinterested friends would take the time to stop and take in the church, they would find an interesting building, fascinating and full of history, as well as being a place for spiritual peace and introspection.

Most of us, even those who are not the least bit religious, will enter a church three times: when we are baptised, when we get married and when we shuffle off this mortal coil. The first time we will be too busy bawling our eyes out as the vicar dips us in the font to really be bothered about our surroundings. The second time we will be too nervous to care where we are, and the third … well!

Yet, there will be other church occasions, when we attend a family christening or friend's wedding or funeral. During the lull in the proceedings we may look up from the pew in which we are sitting and take a look around the building. We may wonder how old it is, or why the windows have only bits and pieces of stained glass, or why there is a staircase in a wall leading nowhere, or why the columns on one side of the church are shaped differently

to those on the other, and wonder why there are only fragments of paintings on the walls. If you, dear reader, are such a person, then this book is mainly for you.

Of course, it is also for all church lovers, for there are those who will browse this book who are seasoned church crawlers who don't need much guidance to find their way around a church. However, I hope that this collection of Buckinghamshire churches will guide them to those they have yet to discover and enjoy.

How do we first understand a church and its history? Perhaps a good analogy is to use a brand-new bicycle just arrived from the factory and gleaming with all one could want to enjoy years of cycling. Our first owner, over time, will have to replace the break blocks as they wear down. He may well get punctures and have to renew the tyres. He may even have to replace the wheels if they become buckled through vigorous cycling. At one point he will fancy he needs better front and back lamps, and also a more comfortable saddle. He will have the misfortune to lose the pump and need to get a new one. After years of bicycling he sells the bike on to another enthusiast. The new owner likes to go off road and changes the tyres to a knobbly, fat, dirt track style. He removes the drop handlebars and replaces them with straight ones. He has no need of the front and back lamps and discards them.

Over the years the bike becomes dirty and scratched, and to a new onlooker is a completely different model to the one originally purchased. In some respects it is, but for one unifying part: the frame. The frame has remained unchanged despite all the other alterations. And one can also see the history and changes of a church in the same fashion. The structure in its bare bones is the same despite the many alterations applied to it down the centuries. Underneath a late Gothic church one can possibly still find an original Saxon building. But how can we identify and recognise these changes?

One of the pleasures of church crawling is to enter a building we have no previous knowledge of and, without resorting to the guidebook, see if we can date the building and learn its history by identifying the different states of construction and what remains. It is always a thrill to learn that we were correct in our attempt to peel back the layers.

Christianity arrived in Britain in the third century AD during the Roman occupation. Yet by the early fifth century the legions departed from our shores leaving the country populated by small enclaves of Christian Romano-British people and the emerging Anglo-Saxons who preferred to practise paganism.

The rebirth of Christianity began with St Patrick's arrival in Ireland in the fifth century and St Columba in AD 563. In AD 597, Pope Gregory the Great sent the missionary Augustine to Britain to convert the heathen pagans. He landed in Kent and was welcomed and accepted by its king, Aethelbert. The king was one of the first converts and gave Augustine land to found a monastery at Canterbury. Augustine would become its first archbishop and it established Canterbury as the spiritual centre of the Anglican church.

From Kent, missionaries set out to spread the gospel and teach the new religion. At first they preached in the open air, yet if they were accepted by the converts they might build themselves a small hut or chapel which would contain an altar

at which the priest would say mass. This, in time, would become the chancel. As the holy man gained followers they would gather around the entrance to the chapel to watch him and try to follow the services. Eventually they would build themselves a small annexe to shelter from inclement weather. This would become the nave. The nave would remain the responsibility of the parishioners, and would be used for secular purposes such as meetings and storage. The chancel was the domain of the clergy. It was their responsibility to upkeep and maintain. Yet many were poor compared to the collective of the parishioners. Repairs and new fashions in building styles were beyond their pocket. Consequently the chancel often lagged behind the development of the church. Ironically, today it is often the most rewarding part of the building, architecturally, as it has mostly remained unchanged.

Surviving Anglo-Saxon churches are rare in Buckinghamshire. The chief example is All Saints, Wing, with its eighth-century apsidial east end. It is, though, possible that the many Gothic churches of the thirteenth and fifteenth centuries throughout the county have Anglo-Saxon roots.

Saxon architecture would last almost 400 years until England became overrun by the Norman Conquest of 1066. The Normans set about taking over and the running of the church. They immediately set about a program of reform which included much rebuilding. Norman or Romanesque architecture is characterised by its solid massiveness. Thick walls, small windows, sturdy round pillars, and semi-circular arches all combined to counteract the outward thrust of the vault. The best example to be found in Bucks is at Stewkley. St Michael's dates from 1140 and remains almost untouched.

We often find evidence of other Norman churches in the county even if the church appears to be of the fourteenth or fifteenth century. At Bradenham, St Botolph's would seem to be fifteenth century, yet it contains a Romanesque south door believed to be the oldest in Bucks.

The Norman style would soon be eclipsed by a revolutionary development introduced from France in the late twelfth century. Church builders discovered that the pointed arch, even though slender and thinner than a Romanesque one, could support more weight. This gave the masons of the day more flexibility in design with a greater emphasis on lightness and refinement. This style is known to us today as Gothic, yet the builders of the Middle Ages would not have used such a term.

The word Gothic was originality meant to be derogatory. It was coined in the sixteenth century by Giorgio Vassari, an Italian architect who looked upon the style of the Middle Ages as unrefined and barbaric, linking it with the Goths who had overrun Europe in the fifth century.

Gothic architecture would come to dominate church and secular building in Britain for the next 400 years. It is divided in to three phases. The first, Early English, is characterised by narrow lancet windows which are deeply splayed on the inside to allow more light into the church. The arcade columns would be either rounded, octagonal or have a cluster of shafts around a central pier. Stiff leaf foliage and dog tooth carving is also a feature of the style. Good examples can be found at St Mary's and St Nicholas', Chetwode.

Early English Gothic lasted throughout the thirteenth century. By the beginning of the fourteenth century Gothic had moved on to its Decorated phase. This style is identified by its elaborately carved window tracery, which was developed into masses of geometrical and curvilinear intersecting patterns.

Decorated Gothic was relativity short-lived, for in 1348 Britain and Europe faced the disaster of the Black Death. Bubonic plague wiped out half the population of England, taking with it the rich and the poor, and also those skilled in stone masonry. It would result in the final phase of Gothic architecture.

Perpendicular, or late Gothic, lasted almost 200 years. It is so called because the windows, which had become wider, had a more pronounced vertical style with mullions, and vertical bars running the full height of the glass. Also the heads of the windows became flatter. This allowed for more light to flood into the church. The best example of this style can be seen at All Saints, Hillesden.

While changes were being made and adapted to the exterior of the church, the interior was another matter altogether. If we could get into a time machine and travel back to the fourteenth century our first reaction when we entered a church would be one of profound shock, for we would be greeted by a sight which would probably overwhelm us and be too garish for our twenty-first-century eyes. All would be colour; it was everywhere. On walls, columns, statues, the roof, the screen and the windows whose stained-glass luminance cast a multicoloured glow throughout the building.

The walls would be adorned with paintings of the saints, scenes and stories from the Bible. On the north wall would be a representation of St Christopher baring the baby Jesus, reminding the parishioners that the patron saint of travellers had guided them safely to their place of worship.

The chancel screen would contain colourful pictures of the apostles. Above the screen was the rood, a carved wooded statute of the crucified Christ flanked by St Mary and St John. To the side of the screen would be a set of stone steps which led up to the rood loft, a space from where musicians or singers would play or chant. Above the rood and just below the chancel arch was the doom painting, a representation of Judgement Day with Christ seated in the centre, to his right the good and the Christian entering Heaven, and on his left the dammed being cast down into hell.

There would have been side chapels cordoned off by painted screens where monks would chant for the souls of the wealthy deceased who had paid for prayers to be said daily for their immortal souls.

The chancel was a place of mystery and awe with its screen which divided it from the nave and the laity. It was illuminated by the great east window, which cast its colourful glow over the priest's proceedings. All was lit by the soft shadowy light of hundreds of candles, which bathed the church in a diffused, sacred radiance. This, together with the aroma and wafting smoke of incense, created a place of veneration and magnificence to the humble, illiterate peasants. It was as if they had entered heaven on Earth. Yet change was on the horizon, which would ultimately alter the appearance of churches for centuries to come.

German monk Martin Luther nailed his protest condemning the corruption of the Catholic Church to the doors of Wittenburg Church in 1517. It was the spark which gave fire to the Reformation, which quickly spread across Europe. In England, in 1533, King Henry VIII's desire to divorce his wife, Catherine of Aragon, so he could remarry and potentially produce a son and heir, brought him into conflict with the Pope. The Pontiff refused Henry and excommunicated him. The king subsequently declared himself Head of the Church of England. In 1536 he began the Dissolution of the Monasteries. The monarch expropriated their income and disposed of their assets.

Yet, despite Henry's argument with the Pope, it was his son, King Edward VI, who was the driving force behind the Reformation in England. During and after his reign, a wave of destructive iconoclasm swept across the churches of Britain. Stained-glass windows and statues were smashed, screens broken down, the rood statue destroyed, chantry chapels abolished, doom paintings taken down and burned, the wall paintings of saints and stories from the Bible whitewashed over and the royal coat of arms placed above the chancel arch. It was a symbolic destruction of Catholic superstition and defiance of papal authority.

By the beginning of the seveenth century church interiors were unadorned, plain, pewed preaching boxes which reflected the new Protestant liturgy. The chancel fell out of use and the sermon became the focus of the service. Gothic architecture, despite its magnificence, also fell out of favour for it harked back to a time of medieval superstition and awe. The few churches that were built after the Reformation were done so in the baroque or classical style, reflecting new ideas from the Enlightenment and advances in science and invention. Yet, further change was on its way, which once again altered the appearance of church interiors.

By the late eighteenth and early nineteenth century, Britain was changing from an agrarian to an industrial society. The advent of coke smelting, steam engines, mines, factories and eventually the railways drew people away from the countryside and into the overcrowded industrial centres to sweat and toil in 'dark satanic mills'. The village was deserted and the church neglected. It seemed that Britain and its people were going to hell in a steam-driven handcart. Something had to be done.

Victorian thinkers such as Augustus Pugin advocated for a return to a medieval rural idyll with planned villages and towns, at the centre of which would be the parish church. Not the Roman or Greek design though, but the style of the early fourteenth century – decorated Gothic. So began the Gothic Revival. Churches would now be built in the style of the Middle Ages, and those whose interiors had been stripped of their Gothic origins were restored to resemble the medieval period. Parts of the Catholic liturgy were reintroduced to reflect the 'new' Gothic layout. However, calamitous change was on the horizon which would ultimately damage the church and see Britain move further down the road to an increasingly secular society.

When Queen Victoria died in 1901, it was the end of an era. The nation was entering a new century, which would come to embrace new ideas, thinking

and attitudes. In 1918 the country was plunged into the horrors of the First World War. Hundreds of thousands of young men were slaughtered on muddy battlefields for what seemed like no reason. Many began to lose their faith. How could such things happen? Where was the church? Where was the Almighty? There was an upsurge in spiritualism as many sought comfort in the belief that they could contact their lost loved ones. But many psychics and mediums proved to be frauds. Further hardships would come in the depression of the 1930s and another dreadful war.

Following the Second World War, Britain had to endure fifteen years of post-war austerity and the threat of nuclear proliferation. The counter culture of the 1960s saw many young people reject the established church and seek out new faiths and beliefs to find answers. The 1970s were a decade of industrial strife, whilst the 1980s and 1990s saw profit, selfishness, greed and indifference. The twenty-first century ushered in the digital age with the internet, computers, mobile phones and the double-edged sword of social media. Within this tsunami of rapid social and technological change the church still survives, but now with a new purpose and different role.

People may have given up on religion, yet have curiously discovered a new form of spirituality. Even though the numbers attending regular Sunday worship have greatly decreased over the last fifty years, and many ancient churches have become redundant, there are those of us who still feel the pull of a church.

Paradoxically, it would seem that the less we use churches, the more we still need them to be there for us. There are many hundreds, perhaps thousands, of non-church-going people who still like to enter a church. They close the ancient oak doors to shut out the madness of the world, and enter the calm, still peace of the nave. We sit in one of the pews and try to gain some sense of perspective. There are no other worshippers, no priests, no chanting monks; we are alone. Yet there is something else – unseen, undefinable, but certainly something. Perhaps it has always been there.

1. ST MARY'S, RADNAGE

At first sight, St Mary's, Radnage, would appear to be a church hiding from the rest of the world. Indeed, one might say that it is concealing itself from the rest of the community. Radnage has an uncommon structure for a village in that it does not have one central point; it comprises a number of separate areas. Town End, Bennet End, City End and Church End spread out over a wide area, a regular occurrence in Buckinghamshire villages where offshoots of the original centre, either farms, or cottage industries, develop as independent hamlets, which nestle together within this remote part of deepest Bucks linked by narrow country lanes. Its name, sometimes spelled Radeneach, or Rodenache, in old documents means 'red oak' in Old English.

Radnage is not mentioned in Domesday Book and it appears from a thirteenth-century document to have been a royal demesne, or crown land. Throughout its history it has been associated with King Henry I, who granted it to the Abbey of Fontevrault in France. King John granted it to the Knights Templar, and King Charles II gave it to one of his mistresses.

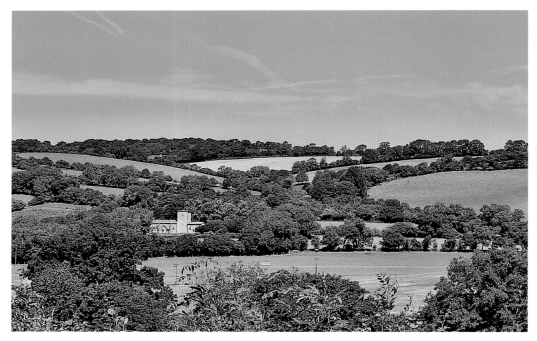

Radnage church in its Chilterns setting.

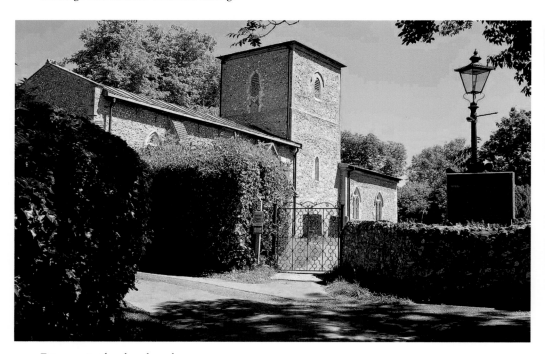

Entrance to the churchyard.

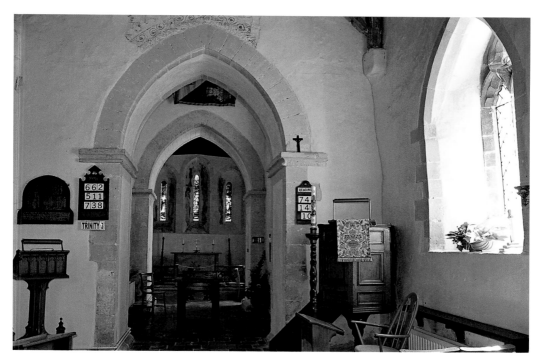

The nave looking east.

However, if the village has no visible centre, its ancient heart is undoubtedly that of St Mary's Church. As one approaches from the south the church reveals itself like a lone, distant ship in sail riding the woods and fields of the Chiltern hills. Further on, and descending through the winding lanes, the church is lost from view within the folds, and one wonders where the building has gone. Soon, as the lane begins to climb, a faded sign by a side road points the way. Here, up a short drive, is St Mary's Church, and its only companion is an eighteenth-century rectory.

Pushing open the graveyard gate we immediately find ourselves in one of the most beautifully situated churches in Buckinghamshire. The views stretch back across the valley to a vista of little fields and beech woods, whilst above, kites swoop and soar as their shrill, whistle cry calls out.

Sitting in Radnage churchyard on a warm summer's afternoon, as my wife and I have often done with a picnic and bottle of wine, it feels as if the rest of the world is far away, and that St Mary's has been forgotten. Indeed that may well have been the case for the church is an architectural gem untouched by the ruining hand of later Victorian restoration.

Built by the Knights Templar in the late twelfth or early thirteenth century, it consists of nave, central tower and chancel with three lancet windows. Originally the church would have comprised just a chancel and tower, which was lower than todays. Entrance to St Mary's would have been through a door in the tower. It

is now blocked, but is still clearly visible. The interior is plain and chalky white, and is pervaded by an odour of ancient mustiness. The walls are adorned with remnants of thirteenth-century painted figures together with texts from the Bible, which were only rediscovered in the 1960s.

The pulpit is late seventeenth century, and the simple font may well hint at St Mary's history stretching back before its thirteenth-century origins, for it is thought to be late Saxon. Incredibly, it was thought lost until being dug up in a neighbouring field.

2. ALL SAINTS, HILLESDEN

Considered to be the finest late Gothic (Perpendicular) church in Buckinghamshire, All Saints, Hillesden, stands in an isolated hamlet at the top of a gentle hill in the remote north of the county. It owes its splendour to the monks of twelfth-century Notley Abbey, near Long Crendon in south Bucks, who, in 1493, rebuilt it following accusations that they had let it become ruinous. In 1538 their abbey was dissolved by Henry VIII, and nine years later, in 1547, Hillesden church and the manor was acquired by the Denton family. In one fell swoop the Dentons had obtained a building recently completed and one they swiftly adjusted to the celebration of their family rather than the church.

The interior is airy and spacious with light flooding in through the grand perp windows and clerestory, bathing the nave, aisles and chancel in a soft honey-coloured glow. There are small transepts and a north chapel as long as the chancel. It is here that the grand monuments to two of the Dentons stand: Thomas Denton (d. 1560) and his wife. The other is to Alexander Denton (d. 1574).

Throughout the church further memorials to the Denton family can be found, and yet are made all the more poignant when one considers the fate which would befall the Denton family in the bloody conflict between King Charles I and Parliament during the English Civil War. Hillesden House, which stood just to the east of the church, was the home of Sir Alexander Denton. He was member of Parliament for Buckingham and also a Royalist. In March 1644 he fortified his house with a garrison of 260 men in support of the king's cause. At the time the house was occupied by members of the Denton family and also some of the Verney family from nearby Claydon.

Such a position could not be tolerated by the Roundheads. A force of 2,000 men under the command of Oliver Cromwell laid siege to the house. The Parliamentarians quickly overcame the defenders, but some Royalists retreated to the church and barricaded the doors. These were soon broken in by musket fire, the scars of which can still be seen today. Those who tried to make a last stand in All Saints were told they would be given quarter and allowed to leave unharmed, yet on exiting the church forty of them were taken into the churchyard and shot. Before the Roundheads departed they entered the church and smashed the stained-glass windows and disfigured the Denton monuments.

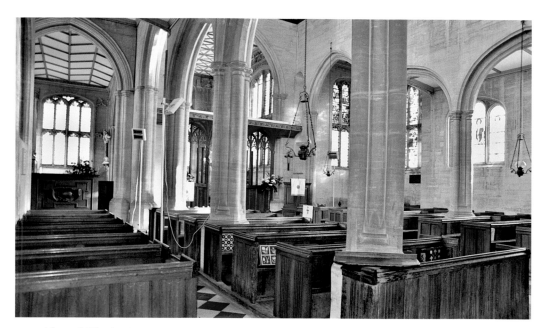

Above: Hillesden interior.

Below: Hillesden church.

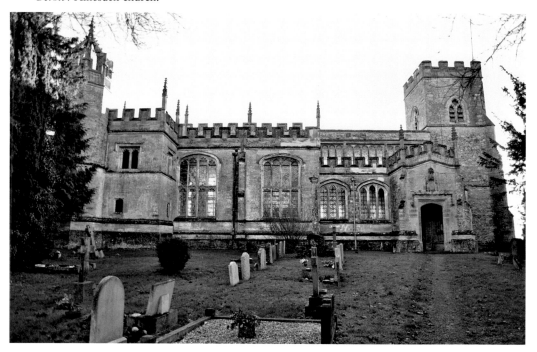

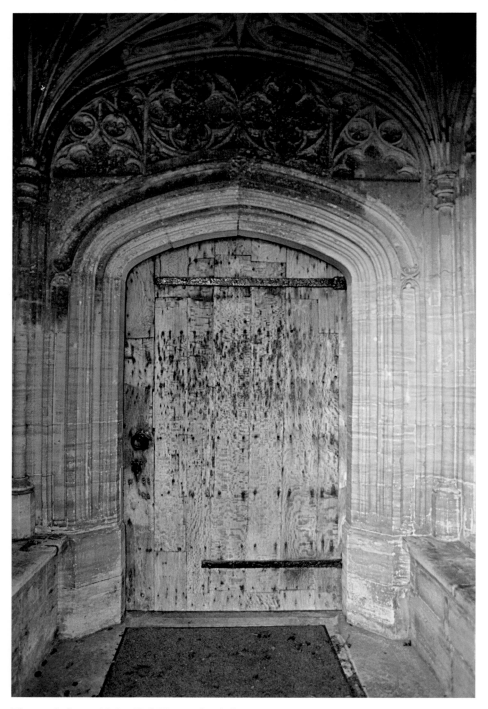

The south door with its Civil War musket holes.

3. ST MICHAEL'S, HUGHENDEN

Hughenden is first mentioned in Domesday Book of 1086 and was called Huchendene, or Hugh's Valley in modern English. However, the name could also refer to the Anglo-Saxon thane Huhha rather than the Norman French Hugh. At the time of the great survey of England, the village was in the extensive estates of Odo, Bishop of Bayeux, who was the half-brother of William the Conqueror.

Today the village of Hughenden has long gone, and the area has become a suburb of High Wycombe – not an unattractive one. As one heads north out of the town the houses and shops abruptly cease, and the traveller is immediately surrounded by a hilly, landscaped park on one side and the gentle, rising slopes of the Chilterns on the other. This is Hughenden Valley, and in 1848 eminent Victorian, later to become Prime Minister and Queen Victoria's favourite, Benjamin Disraeli made it his home when he bought the estate including Hughenden Manor (see Stately Homes).

Disraeli decided to not only remodel his house, but also rebuild the twelfth-century church of St Michael, the only remaining part of ancient Hughenden. The building stands at the side of the drive leading up to the manor, and is known locally as the church in the park. The views from the churchyard give an attractive vista over the park and surrounding Chilterns.

Like many Victorians of the time, Disraeli wanted to return the appearance of the church to its medieval origins. Indeed from 1840 the love of all things medieval became known as the Gothic Revival.

Between 1874 and 1890 he set about rebuilding St Michael's. All that was retained from the medieval church was the north chapel, the sixteenth-century arcading between it, the chancel and a late twelfth-century font.

The interior, in particular the chancel, is a perfect example of how the Victorians imagined the medieval period of church decoration. It is a romanticised version of fourteenth-century Gothic. It is separated from the nave by a low, open, wrought-iron screen. The floor is covered with ceramic tiles and the walls decorated with wall paintings depicting the Nativity, the four evangelists and the Prophets. The east window is set with nineteenth-century stained glass.

On the north wall is the white marble memorial to Disraeli, Prime Minister in 1868 and 1874–80, who died in 1881, which was erected by Queen Victoria.

For those keen on St Michael's medieval past the north chapel is of curious interest. In a niche behind the chancel's north wall is a rather macabre, early sixteenth-century stone cadaver, which seems as if it has stepped out of the pages of an M. R. James ghost story. It is a somewhat eerie spectacle to come across, as I discovered when I was alone in the church one cold, dark winter's afternoon.

Further mysteries are to be found in the north chapel. Within are effigies of four knights. One is genuine and dates from the fourteenth century, whilst the other three, which were seemingly executed in the fifteenth century, are fakes. The workmanship would appear to be obviously crude, and it is remarkable how they could have fooled anyone with their inferior craftsmanship. They

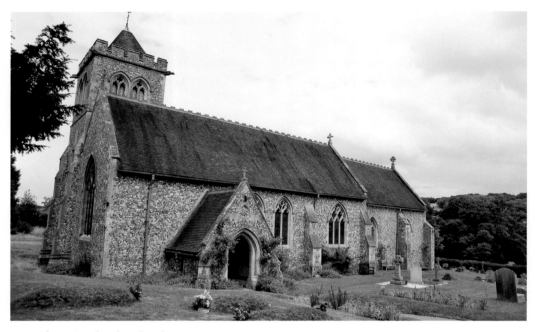

Above: Hughenden church.

Below: The restored chancel.

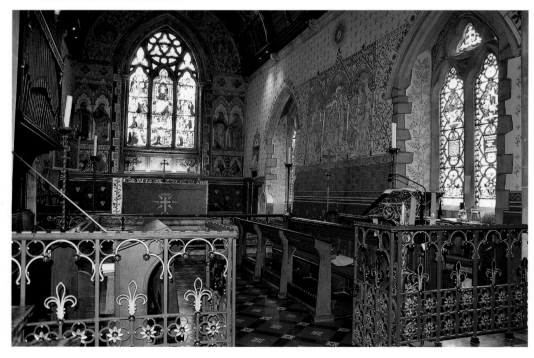

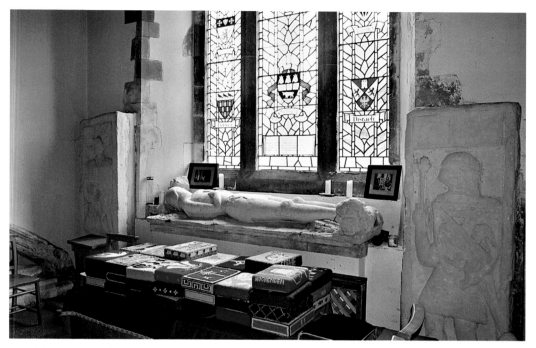

The chapel with its fake tombs.

were fashioned in the sixteenth century to give a spurious connection of a local family, the Wellesbournes, to Simon de Montfort, the father of the English parliament.

4. ALL SAINTS, WING

All Saints is one of the most important Anglo-Saxon churches still standing not only in Buckinghamshire, but also England. It is thought to date from the late tenth century, and is unique in that it retains its crypt, above which stands a grand, seven-sided apsidal east end, a Saxon nave, aisles and west wall.

The Saxon origins of the church and village reach far back. An ancient track, part of the prehistoric Icknield Way linking Oxford with Cambridge, once passed through Wing. The name of the village occurs in Old English, *c.* 966–975, as Weowungum, possibly meaning 'the sons or family of Wiwa'. Alternatively it is thought the name means 'the dwellers or disciples of the heathen temple'. This heathen temple might refer to a Roman structure which had stood on the site beforehand. It is also possible that the site of All Saints had been used as a place of worship long before the legions arrived on our shores.

The interior of the church is one of lofty massiveness, whitewashed and scrubbed clean. The Saxon arches from the nave to the aisles are simple openings cut through thick walls. The apse is higher than the nave and is entered through one of the largest arches of its period in England.

Curiously the Normans seemed to have left the church alone, for the later additions to the fabric came in the thirteenth century, with the construction of a south aisle, and the tower, clerestory and apse windows being added in the fifteenth century.

Inside the church one will also find many impressive and important monuments to the Dormer family. They came to nearby Ascot Hall in the 1520s, and their memorials dominate the church. Most impressive is that to Sir Robert Dormer (d. 1552). An architectural composition of English and Renaissance details, it is considered to be the best example of its style and date in England.

Other grand Dormer monuments face each other across the apse. William Dormer (d. 1575) and his wife with kneeling figures was completed in 1590. A further memorial is to Sir Robert, 1st Lord Dormer (d. 1617), and his wife.

Although Wing is today a somewhat busy village with perhaps a little too much traffic, its church lies tucked away along Church Street surrounded by pleasant terraced cottages. All Saints is undoubtedly an architectural and historical must see for the church crawler eager to experience the work of our Anglo-Saxon ancestors.

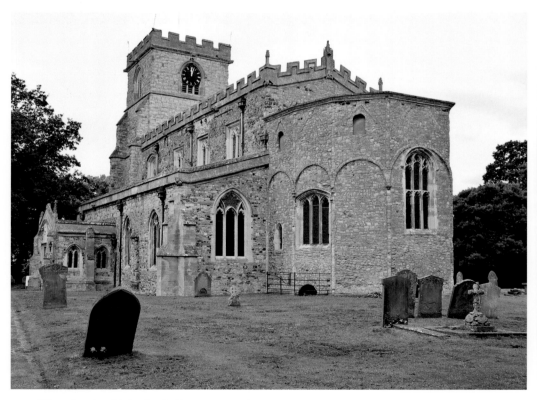

Wing church with its Anglo-Saxon east end.

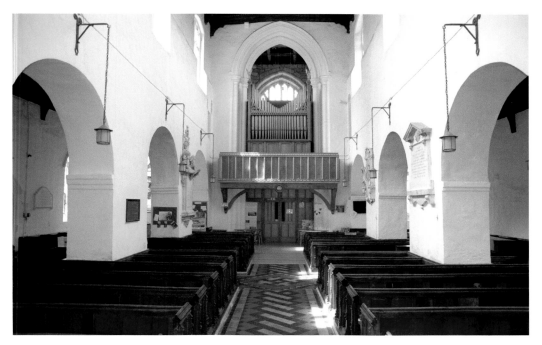

The nave.

5. ST MARY'S, WILLEN

St Mary's Church, Willen, is indeed an oddity, but one worth the effort to seek out. Like Stewkley church, it would seem to be a building totally out of sync with its surroundings, for here in the brave new world of Milton Keynes new town stands a seventeenth-century gem of a church which one might feel would be more at home in the city of London.

St Mary's was built in 1680 on the site of a medieval chapel or church for the headmaster of Westminster School, Richard Busby, by Robert Hooke, a friend of Sir Christopher Wren, and designer of the monument in London which commemorated the Great Fire. Hooke had been a pupil of Busby at Westminster. He regarded himself more as a scientist than architect, and made the astonishing claim that it was he who had discovered the laws of gravity, and not Sir Isaac Newton.

Whatever the truth of the claim, his church is a charming building. The original chancel was demolished in 1861 and an apsidal Victorian one added. The church is enclosed in a graveyard with old brick walls and iron gates, and is best approached from the west along an avenue of lime trees. The lowering western sun glows against the orange bricks of the tower as it looks out over fields and the vast expanse of the newly created Willen Lake.

What would Busby and Hooke make of it all if they could return? A new town? An artificial lake? When Sir Nikolaus Pevsner visited the church in 1960 for its inclusion in his *Buildings of England: Buckinghamshire*, the location must have

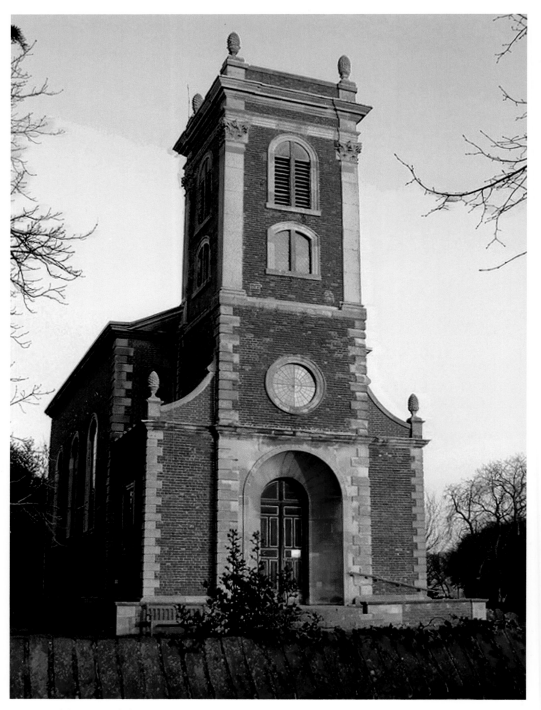

A golden sunset lights the classical Willen church.

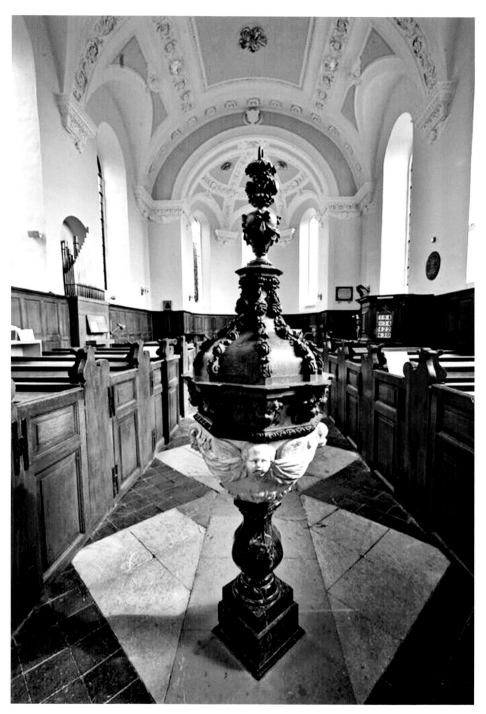

The interior.

looked little changed from when the church was completed in the seventeenth century: a small, medieval village by the River Ouzel, with church, vicarage, two large farms and a scattering of cottages.

In 1967, Willen was swallowed by the proposed new town of Milton Keynes. Despite the needs of the expanding city, the area around the church retains a somewhat peaceful aspect. Certainly Busby and Hooke would still recognise the interior of St Mary's. The church is entered by the west door set into a stone-faced recess in the tower similar in design to Wren's church, St Mary-Le-Bow, in the city. Within is a delightful, unrestored interior. Pews, stall fronts, west door, wall panelling, organ case and font are all original, as is the pink and white exquisitely decorated barrel-vaulted ceiling.

6. Quaker Meeting House, Jordans

The meeting house at Jordans has been described as the Westminster Abbey of the Society of Friends, or Quakers, a title bestowed upon the society's firebrand preachers who would literally shake and quake with religious fervour as they recited the scriptures. Although it is indeed the most important Quaker building in the world, and also the last resting place of one of its most illustrious 'friends', William Penn, the comparison with Westminster Abbey is as contrary as one could

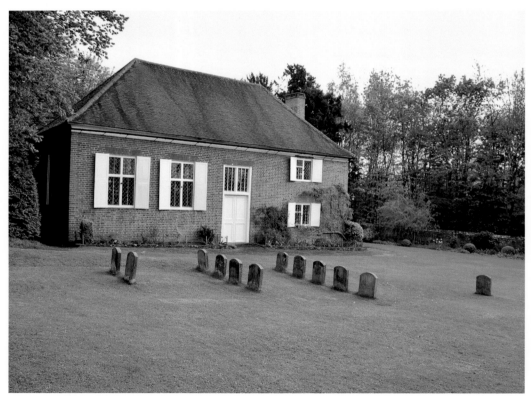

The meeting house.

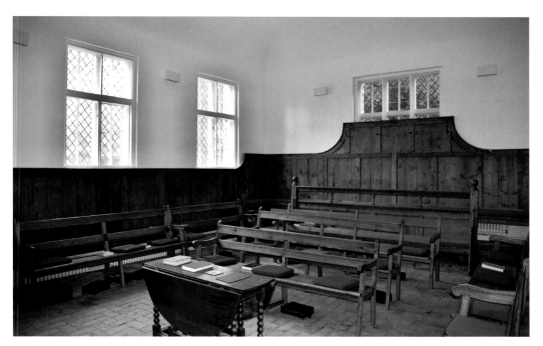

The plain interior.

imagine, for here the visitor will find a plain, simple brick building, with a hipped roof covering a one-storey chamber. The interior is an unadorned, wood-panelled room with plain benches, a brick floor and shuttered windows looked down upon by a creaking gallery; a Spartan place of worship reflecting the Quakers' egalitarianism and rejection of pomp and ceremony.

It was built in 1688 following King James II's Declaration of Indulgence in 1687 and subsequent Toleration Act of 1689, which offered all Dissenters freedom of worship. Prior to this, Quakers had to meet in secret with the threat of prosecution and imprisonment for their beliefs. South Buckinghamshire had long had a tradition of religious dissent. The Quakers had been gathering in the Chilterns for many years before the building of the meeting house. William Russell, a prominent Quaker, was a proprietor of the adjacent Jordans farm in which the society came together in secret. The farm still stands, and retains relics and reminders of those Pilgrim Fathers who escaped England for the New World so they could worship in freedom. Part of the farm's timbers, and possibly part of a cabin door, are said to have been salvaged from the *Mayflower*.

William Penn was a Buckinghamshire man. He claimed the nearby village of Penn as his ancestral home. He founded the city of Philadelphia and the settlement of Pennsylvania is named after him. He, along with his wife, was a frequent attender at the meeting house. In 1718 he was buried in the grounds along with other prominent friends.

7. St Michael's, Stewkley

Stewkley church is an incongruous architectural gem. Seemingly out of place in a large, suburbanised village, it has managed to survive as the modern world has grown around it. Built between 1150 and 1180, it is a near-perfect example of Norman architecture with minimal later Gothic additions. The west front to the main road displays exuberant zigzag carving over a triple-arched west door. The zigzag design is continued above the door within a single typical Romanesque window.

To enter the church is to partly step back over 800 years, for it is mostly unrestored, with the Victorians restraining themselves to just a liturgical reordering of layout.

The twelfth century would have seen a church crowded with a screen, icons, paintings, the soft glow of candles, earth floors, the grey wafts of incense and the constant coming and going of villagers in need of spiritual fulfilment. Today the place is scrubbed and orderly.

The building is divided into three cells: nave, tower and chancel. Yet one cannot be unimpressed by the beauty of the carving on the tower and chancel arches. Although typically massive in the Romanesque style, the flow and grandeur of the design retains a solid gracefulness.

Stewkley church is undoubtedly a survivor, and an architectural and historical delight. Stepping back outside the building into the rush and flow of the twenty-first century can be a little jarring. As we take one last look back, perhaps it is

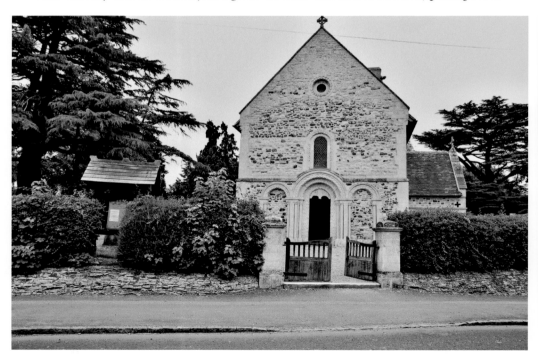

The Norman west front.

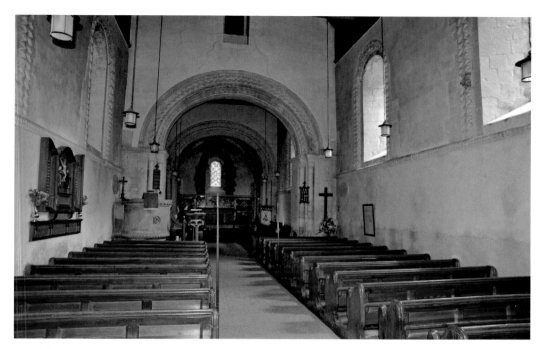

The nave.

sobering to remind ourselves that the people who designed and built the church were Normans who would have spoken French. Those Anglo-Saxon peasants who entered to perform their daily devotions spoke an English unintelligible to us today.

If they could return to Stewkley today they would no doubt still recognise the church they originally worshipped in. Perhaps more puzzling to them would be the idea that it was once proposed to move the church from its current position. In the 1970s the church narrowly escaped disaster when it was proposed to build London's third airport at nearby Cublington. The authorities generously offered to move the building, although to whereabouts wasn't made clear. Happily sanity prevailed. The third airport is yet to find a home, and Stewkley's Norman glory remains to please us all.

8. St Lawrence's Church, West Wycombe

There are a number of buildings in West Wycombe which not only show the eighteenth-century disdain for the established church of the day, but also the eccentricities and peculiarities of the landed gentry.

The church of St Lawrence was built between the thirteenth and fourteenth centuries, on the summit of Church Hill. However, given the centuries-old religious significance of West Wycombe Hill, it is probable that an earlier, Saxon place of worship stood on the site. It is thought it originally served the village of Haveringdon, which no longer exists.

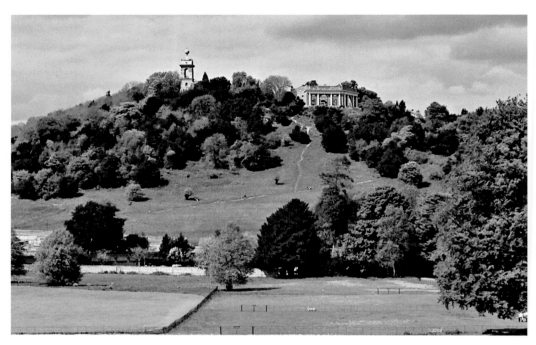

Above: The tower of St Lawrence's peeps from its Chiltern hill.

Below: Looking from the east.

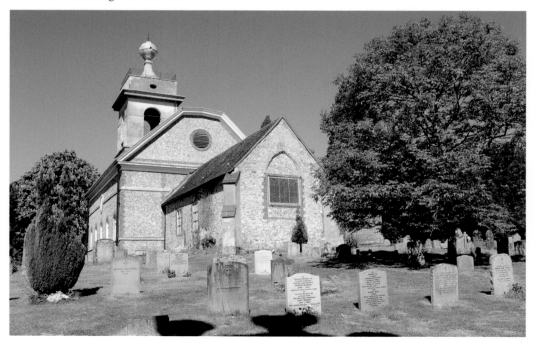

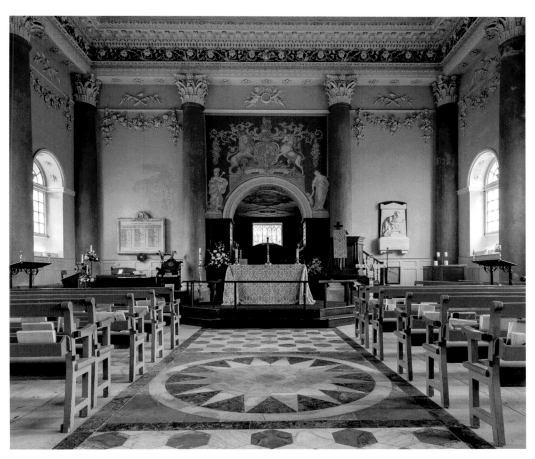

The classical nave.

The present church is really a building with two histories. The early medieval work is still visible in the rough masonry of the west tower, the thirteenth-century chancel and the remaining faint tracery of its Gothic east window. The interior, however, is a different matter altogether. It is an extraordinary, opulent and ultimately ironic reordering of a church interior.

When lord of the manor, Sir Francis Dashwood, returned to England from the grand tour of Europe in 1761, he set about remodelling the interior of St Lawrence's Church with designs based on the classical architecture of Rome and Greece.

Many church interiors in England had, from the late sixteenth century, undergone radical changes to their layout following the introduction of the Book of Common Prayer during the reign of Edward VI (1547–53). Orders were given that all Catholic and Popish superstitious imagery and practices were to be removed from the church. Alters, stained glass, statues, carvings and wall paintings depicting the saints were destroyed to be replaced with the plain, sober box pew interior of English Protestantism.

St Lawrence's Church must have resembled this when Dashwood took off for his grand tour. Yet Sir Francis, perhaps with his tongue in his cheek, seems to have flown in the face of this new liturgical layout and took his church back beyond medieval superstition.

He rebuilt the church in the popular classical manner of the day, heightening the tower and topping it with a golden globe large enough for his cronies to sit and get drunk in. He removed the arcades and replaced them with rich, Corinthian columns painted in an imitation exotic marble. The walls are decorated with a palm frieze in the Rococo style with garlands, flowers and doves. The lavish decorated ceiling is based on drawings of the pagan temple of the sun at Palmyra in Syria, whilst the chancel ceiling is adorned by a painting of the Last Supper. It seemed like a bizarre combination of Christianity and paganism. It was, to one visitor, 'A very superb Egyptian hall'.

For us today, it must seem extraordinary how anyone could be allowed to redesign a church in such a fashion. Or was it Dashwood, in his own, whimsical, aesthetic manner, sticking two fingers up to the Church of England?

9. St Peter's Church, Loudwater, High Wycombe

To many people Loudwater is a suburb of Wycombe one passes through either on their way to the centre of town, the M40 motorway or Flackwell Heath. In fact it is still regarded as a hamlet, yet despite its modern housing and roaring traffic, it can date its origins back to the thirteenth century where it is referred to in manorial rolls as 'La Ludewatere' – no doubt a reference to the rushing River Wye.

There are few remaining old buildings in Loudwater to indicate its antiquity; Loudwater House and its neighbouring half-timbered cottage on the London road are just two. However, one more building remains which reminds us that the location was once a sleepy hamlet.

St Peter's Church was built in 1778. At that time the village would have been distant from Wycombe and surrounded by fields and woods. The church is interesting not only architecturally, but also as a good example of the changing fashions in church building which stemmed historically from the Tudor and Stuart periods, and leading up to the Victorian age.

St Peter's is a plain, red-brick, rectangular building which seems remote from the grand churches of the medieval era. Its design reflects the change in how religion was perceived and celebrated in the Georgian period. Following on from the Dissolution of the Monasteries by Henry VIII in 1543, churches in England discarded all the trappings of Popish superstition. Out went the stained-glass windows, statues, painted walls and the smell of incense. In the Georgian era religion became an intellectual process of rational belief. The sermon took precedence over the sacrament, and many churches became little more than unadorned preaching boxes. St Peter's original design demonstrates this.

However, in 1840 a new view on religious service and practices developed. The Victorians were shocked at the horrors of the Industrial Revolution, which seemed to be destroying the very heart of England's green and pleasant land

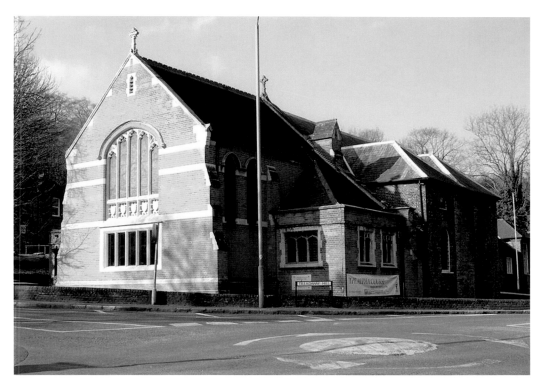

St Peter's Church, Loudwater.

with grimy, smoky cities peopled by exploited workers. Their idea was to look back to an idyllic past of medieval Britain. This yearning was reflected in church design and architecture as Victorian architects built churches in the Gothic style. It didn't always work. The Gothic additions to St Peter's were added in 1903. They are perhaps a bit out of place, architecturally, as are the modern additions to the original Georgian building. Yet they show, at least in design, the changing religious, social and architectural attitude to church buildings.

10. HOLY TRINITY, PENN

Like many of England's ancient churches, Holy Trinity is a product of centuries of change and development. It dates from the twelfth century, although it is entirely possible that a Saxon place of worship had previously stood on the site. The building is composed of a nave, south aisle, chancel and a solid, short west tower. The chancel was remodelled in 1733, yet many of its eighteenth-century furnishings would have been replaced during the Victorian era. However, the pulpit dates from the remodelling, and originally came from the Curzon Street chapel in London. The Curzon family were responsible for restoring the church.

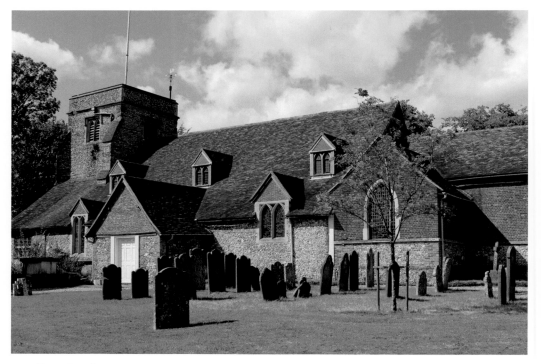

Penn church.

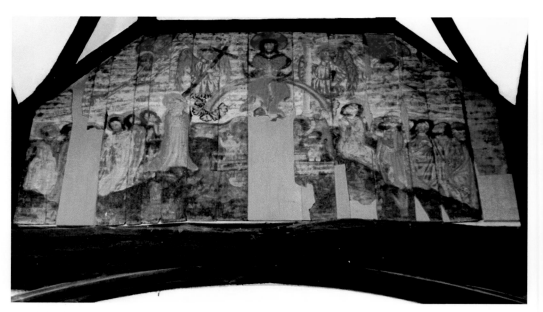

The doom painting.

The interior contains a rare fifteenth-century doom painting painted on oak panels above the chancel arch. Doom paintings depicted Judgement Day when Christ would come and judge those who were worthy of a place in Heaven, and also those sinners who were destined to a fiery hell. It is thought to be one of only five such doom paintings on boards to survive in England.

Perhaps the most interesting aspect of the church are the families connected to the village and those who lie in Holy Trinity churchyard. Six grandsons of Sir William Penn, founder of Pennsylvania in America, lie within the vaults, and their memorials are dotted around the church. Sir William Penn established the city of Philadelphia, recognised as the first capital of the United States. Penn claimed the village and Buckinghamshire as his ancestral home.

Within the churchyard are two graves with, perhaps, a less than noble, but nonetheless intriguing history. Here one can find the last resting place of David Blakeley. He was murdered outside a London pub in 1953 by Ruth Ellis. She was found guilty and became the last woman in Britain to be hanged. Nearby are the graves of the Maclean family. Their son, Donald, was a British diplomat who was one of the Cambridge Five spy ring, which conveyed secrets to the Soviet Union shortly after the Second World War. He was discovered, but defected to Russia in 1951. In 1983 he died and requested that his ashes be returned to England and scattered on his parent's grave in Penn churchyard.

11. ST NICHOLAS', NETHER WINCHENDON

The parish church of St Nicholas, Nether, or Lower Winchendon, like the village it provides with spiritual guidance, seems to be a world away from the hurly-burly of modern-day Buckinghamshire. It sits within a valley of soft rolling hills and the water meadows of the River Thame beneath its namesake up on the Chiltern ridge, Upper Winchendon.

There has been a church at Lower Winchendon as far back as the eleventh century, when the manor belonged to Queen Edyth, wife of Edward the Confessor. The building we see today, however, is early thirteenth century, but there are ancient stones at the base of the tower indicating that a Saxon church once stood on the site. Apart from its location, the chief attraction of St Nicholas' is its interior, for it has remained remarkably unchanged since the eighteenth century.

It is a fine example of how village churches looked before the Victorian restorers got to work. Although the chancel was rebuilt in 1891, it doesn't detract from the Georgian atmosphere inside. Within there are box pews, a seventeenth-century, Jacobean, three-decker pulpit, west gallery, Hanoverian royal arms of George 1V, organ and chandeliers. There is also fifteenth-century English and sixteenth-century Flemish stained-glass windows. They were removed from the church during the Civil War to avoid destruction and hidden in Nether Winchendon House, only being returned to the church in 1958. All is appropriately lit by lamps and candles. It does indeed feel like one has stepped back to another time.

Above: The church from the south.

Below: The nave looking from the chancel.

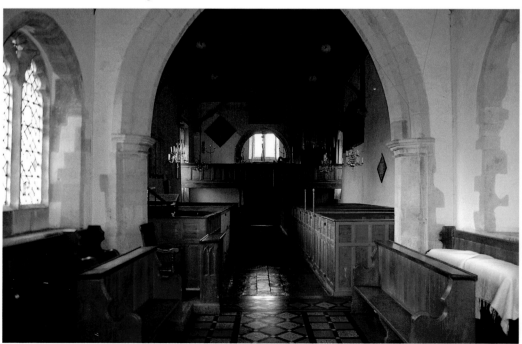

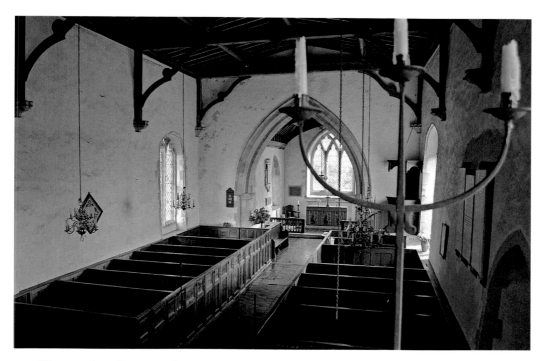

The nave from the west gallery.

This feeling is continued outside in the churchyard. As the visitor relaxes on the bench in the warm sunshine, the village sits dreamily in the afternoon. Here one will not find a pub, post office, or local shop. Passers-by are rare, and the solitary cottages straggle along the lane past the sensibly retained red telephone box, and all sited within beautiful Chilterns scenery. One almost expects Miss Marple to come pootling down the hill on her bicycle en route to solve another murder. Nether Winchendon and its delightful church are a reminder that there are still places in England where one can escape the madness of the world.

12. ST NICHOLAS' AND ALL SAINTS, GREAT AND LITTLE KIMBLE

The busy A4010 between Princes Risborough and Aylesbury might seem an unlikely place to discover gems of Buckinghamshire. The villages of Great and Little Kimble, which lie along its route and sit virtually within shaking hands distance of each other, seem to have been swamped by speeding traffic; a location one would probably think not worthy of stopping in, content to rush through on the way to somewhere else. But they would be wrong, for here the history buff, if they look closely, can find fascinating remnants and reminders of Britain's turbulent past.

The name Kimble is thought to be Anglo-Saxon (cyne bell), meaning 'Royal Hill', although other sources suggest that the name may derive from Cunobelinus, King of the Catuvellauni, a British Celtic tribe who ruled this part of southern Britain from around 4 BC to AD 41 until the invasion of the Roman legions.

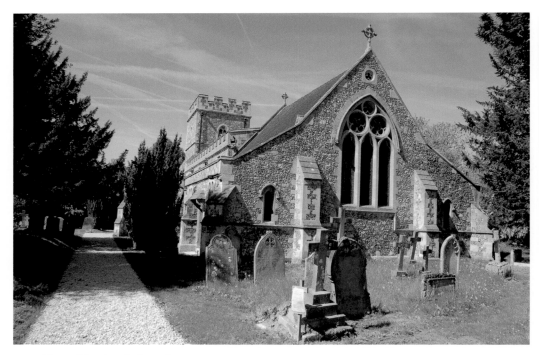

Above: The church from the west.

Below: Nave wall paintings.

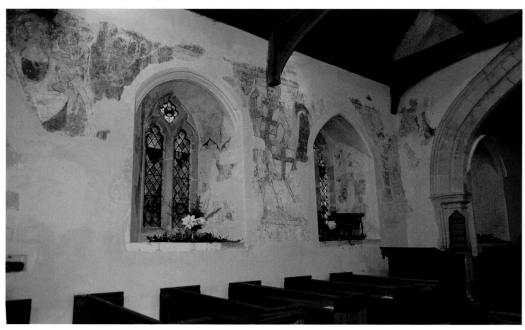

Above: The nave during restoration.

Below: Nave wall paintings.

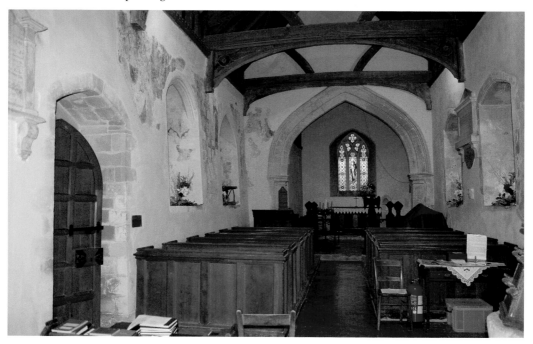

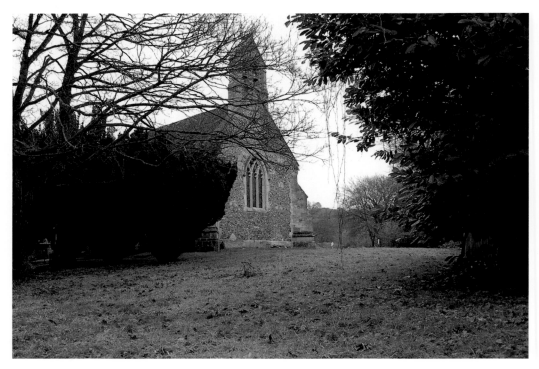

Above: The church from the east.

Below: Nave wall paintings.

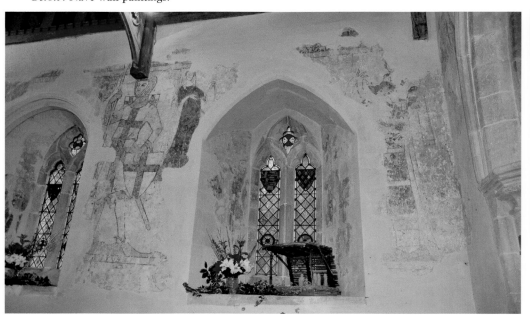

The Anglo-Saxon description of Royal Hill may well refer to the fact that three quarters of a mile south-east of Great Kimble church, and on the summit of Pulpit Hill, there are the remains of an Iron Age or Bronze Age hill fort dating from the 1st millennium BC. Its true purpose is unknown, but it could well have served as a Catuvellauni royal stronghold.

Further reminders of Britain's ancient past are to be found on the west side of Great Kimble church. Adjoining the churchyard and fronting Church Lane is a funeral mound or barrow. It is tempting to link the burial mound with a long-lost Catuvellauni king, but it is thought to date from the Roman period, possibly containing a one-time resident of a Roman villa which stood on the east side of Little Kimble church.

Evidence of the Norman Conquest of England can be discovered to the east of Little Kimble church. Here can be found the mounds and banks which are all that remain of a motte-and-bailey castle erected soon after 1066. It was constructed by the new Norman landowner, who was aware that he was surrounded by dispossessed and hostile Englishmen.

Although from the outside appearing seemingly modest and uninteresting, and having the look of a Victorian cemetery chapel, All Saints, Great Kimble, dates from around 1250 with windows in the north wall of the chancel dating from the early fourteenth century. The north and south porches, along with the doors and windows of the nave, also date from this period. The chancel contains thirteenth-century medieval tiles possibly taken from the ruins of Chertsey Abbey in Surrey. However, the church's chief glory is its wall paintings.

Dating from the early fourteenth century, they are the most extensive in Buckinghamshire. They include St Francis preaching to the birds and a large figure of St George, but not all can be identified. There seems to have been a doom painting on the west wall, depicting a devil pushing two women into the mouth of hell. On the north wall facing the south door is St Christopher.

All Saints is a perfect example of never judging a church by its outward appearance. The same must be said of St Nicholas', just a stone's throw away up the road. The building was begun in the twelfth century and added to during the thirteenth and fourteenth centuries. However, like most medieval churches in England, it was completely restored in 1876–81.

St Nicholas' Church's fame rests upon the events which took place there in January 1635. Sir John Hampden was a local landowner and Member of Parliament for Aylesbury. In 1635 King Charles I needed money to improve the navy. A levy was traditionally collected from coastal ports and towns, but the king tried to impose the tax on all counties in England, a move that was, in the eyes of Hampden and his supporters, unconstitutional. In January 1635 Hampden and other Buckinghamshire landowners met at St Nicholas' Church and all agreed to refuse to pay the tax. It was a decision which would ultimately lead to civil war, the beheading of the monarch and, for a period, turn England into a republic. Britain and the monarchy would never be the same again. Momentous events in the history of the nation, the spark of which was ignited in this obscure Buckinghamshire church.

13. St Botolph's, Bradenham

Architectural historian Sir Nikolaus Pevsner was pleasantly pleased when he first set eyes on Bradenham village. The combination of a spacious green, manor house and grey flint church are not easily forgotten, he wrote in his guide to Buckinghamshire. He was quite right. To come across Bradenham village on a cloudless summer's afternoon, with a cricket match in full swing on the green, the sound of leather on willow accompanied by a ripple of gentle applause, and the parish church tower chiming the hours, is perhaps, for many, the perfect, idyllic vision of England. Yet he may have been disappointed in the church.

The church of St Botolph dates from the eleventh century, yet was so extensively restored in 1863 as to look Victorian. The chancel, screen and rood loft are all twentieth century, as is the south porch. However, underneath the hand of the restorers is a good example of how a church can still attract our interest and detective work despite the zeal of the Gothic revivalists.

Bradenham is mentioned in Domesday Book, and its probable that a Saxon place of worship stood on the site of the present church. The narrow nave, south and north walls, which are of an unusual height, hint at Saxon origins. The Norman south doorway is of interest as it's the oldest in Buckinghamshire, yet with elements which are still Anglo-Saxon. Did Saxon craftsmen, resentful of their new masters, try to retain a small part of the country's heritage with a few pre-conquest details. The main body of the church, although heavily restored, dates from the fourteenth century. The tower is perpendicular Gothic and dates from 1420.

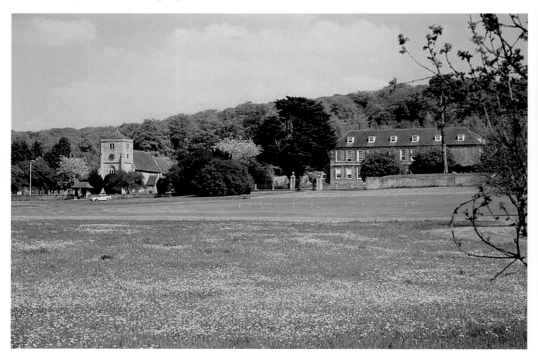

The church and manor house.

The Norman south door, the oldest in Bucks.

South door from the nave.

The church contains the Windsor chapel, which was built in 1542 and retains some of its eighteenth-century Heraldic glass in its east window. Here one will also find the fine seventeenth-century monument to Charles West.

Bradenham's other attraction is, of course, the manor house. It dates from the mid-seventeenth century with elements of a former Tudor mansion. The first house was built by William, Lord Windsor, between 1543 and 1558. William's son, Edward, entertained Elizabeth I at Bradenham in 1566.

It was also once the home of Isaac Disraeli, father of British prime minister Benjamin Disraeli, who lived there for part of his early life. Isaac died in 1848 and was laid to rest in the church.

14. CHURCH OF THE ASSUMPTION, HARTWELL

Following on from the Dissolution of the Monasteries and King Henry VIII's break with Rome in the mid-fifteenth century, very few churches were built in England. The existing places of worship had to be adapted to accommodate the

new Protestant liturgy. Also at this time the predominant style of English church architecture of the preceding 500 years, Gothic, began to fall out of favour. Its arches and pinnacles seemed to hark back to a time of superstitious Catholic iconography; indeed the style was considered barbaric by some commentators who linked it to the architecture of the Goths (hence the title Gothic). Churches were stripped of their statues, stained glass and wall paintings. Screens were removed and the chancel began to be less used. The sermon took precedence and high pulpits and box pews were installed so that the parishioners could listen to the vicar preaching for hour upon hour.

By the end of the sixteenth century and the beginning of the seventeenth, new ideas and attitudes ushered in by the Enlightenment began to find expression in the classical architecture being used in church buildings. In 1623 Inigo Jones designed St Paul's Church in Convent Garden in London. It was the first entirely new church to be built in the capital since the Reformation. It is little more than a large preaching box, yet its façade resembles a Roman temple. This preference of the classical style can be seen in the rebuilding of the Gothic churches by

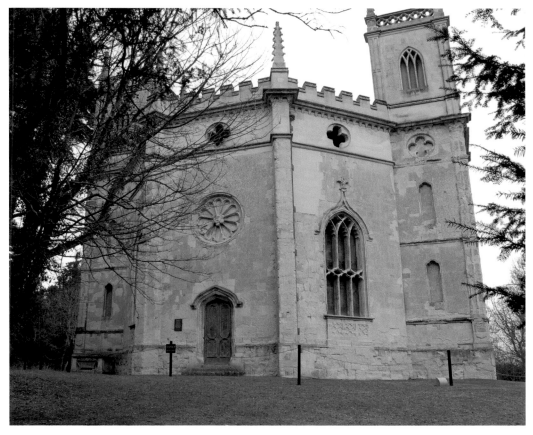

Hartwell church.

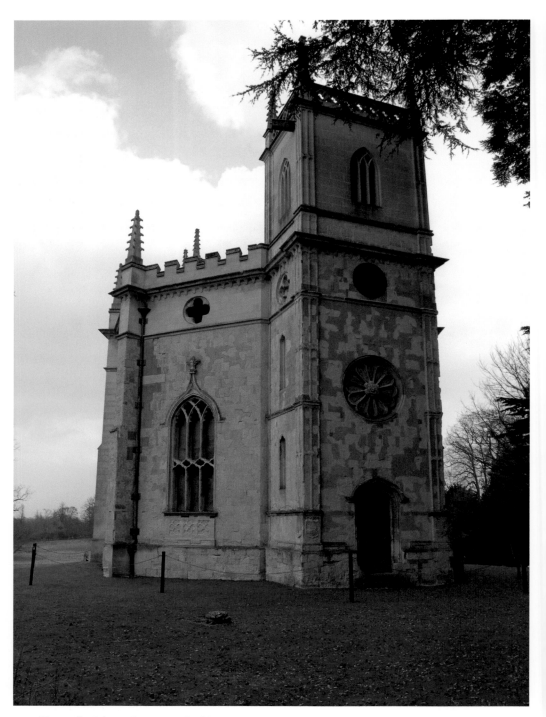

Hartwell, eighteenth-century Gothic.

Sir Christopher Wren that were destroyed in the Great Fire of London. All are in the baroque/classical style, with his masterpiece, St Paul's Cathedral, taking precedence. During the eighteenth century, classical architecture proliferated throughout Britain, in particular in the design of the country's stately houses. Yet Gothic still had its admirers.

In 1756, Sir William Lee, the then owner of Hartwell House, just outside of Aylesbury, commissioned architect Henry Keene to design and build a Gothic church within the grounds of his home. The Church of the Assumption stands on a little mound in the park and is an important early Gothic Revival church. It is thought that Keene was inspired by the medieval chapter house at York Minster.

It is octagonal, and has east and west towers. The north and south bays of the church have rose windows, whilst the other windows are tall with crocketed ogee arches, and are Gothic in appearance but incorrect in style. The church was originality adorned with a pretty, plaster fan-vaulted ceiling, but during the war the military requestioned the lead form the roof leaving the fan vault to the mercy of the elements, leading to its it eventual collapse.

At the time of writing I am happy to report that the roof has been repaired and the church is now vested in the care of the Churches Conservation Trust. However, the interior is still out of bounds to the public.

Hartwell church is indeed an interesting building and its early Gothic Revival design would go on to inspire and encourage the later Victorian love of all things medieval in the 1840s. Yet, one might say that the two revivals came from different origins. The eighteenth-century interest in Gothic was born out of the romantic tradition as a reaction to the increased advances in science and the rise of rationality and reason. The romantics wished to return to a world of nature and the exaltation of the senses and emotions over understanding and the intellect. The Victorians saw a need for Gothic as a reaction to the horrors of the Industrial Revolution and a desire to return to a medieval idyll.

The Church of the Assumption was no doubt planned as a required place of worship for the Hartwell parishioners. Yet one wonders if Sir William Lee also saw it as a folly, or a building of romantic, melancholy pleasure to be viewed from his house.

15. ST GILES', WATER STRATFORD

The churches in this book were chosen not only for their architectural and historical interest, but also for certain curiosities associated with them. The church of St Giles at Water Stratford is one such. The building stands on a small rise in a pleasant village of timber-framed and stone and brick cottages. It is a small church with a fourteenth-century, pyramidally capped west tower and Decorated and Perpendicular windows with a low chancel. The church was rebuilt in 1828 reusing original materials. The church's chief architectural interest is the Norman south and north doorways, which retain their beautiful tympanums.

So much for the architectural details. If and when the reader gets to visit the church, sit for a while in one of the pews, or out in the churchyard, and think about the extraordinary events which took place at Water Stratford over 300 years ago.

Water Stratford church.

The village of Water Stratford, 2 miles west of Buckingham, would seem to be the last place one would think of escaping to in the advent of a prophetic, fiery Armageddon. Yet, this sleepy Bucks backwater was, in 1690, besieged by a deluge of fanatical disciples convinced that it was the only place on Earth which would be spared the ending of the world.

In 1674 John Mason became parish priest of St Giles' at Water Stratford. He was a Puritan and was much admired by his fellow clergy. He was a man of gentle disposition and moderate views, but he turned to Calvinism. One of its beliefs was that salvation is preordained and that God has chosen from eternity those who are to be saved regardless of how devout and spotless a life one leads on Earth.

In 1690 the good priest was hit by three successive personal blows. A scripture chronology he had worked on for years was rejected by the church authorities and he grieved over his wasted time. Secondly, his closest friend died, and this blow was devastatingly followed by the death of his beloved wife.

Overnight, John Mason became a changed man. He began to experience strange dreams, nightmares and delusions, which haunted his waking hours. His preaching began to take on an alarming dimension. On Sunday mornings he would thunder forth from his pulpit that he was the prophet and miracle worker Elijah, and that he could summon up the dead and bring down fire from Heaven.

Unsurprisingly, Mason's superiors in the church began to get a little concerned. Not so his parishioners. Hundreds of people from the surrounding area descended on the Buckinghamshire village eager to hear the word of the new messiah. So great was the impassioned multitude that there became no room in the church and the crowds packed into the churchyard to listen to Mason as he addressed the throng from one of the church windows.

Eventually the church authorities sent Revd Maurice, rector of Tyringham, a close friend of Revd Mason, to Water Stratford to report on what was happening. On his arrival he found the village in pandemonium. Throughout the rectory, men, women and children were running up and down the stairs bellowing, laughing and clapping as if the day of judgment was just around the corner.

Whilst Mason's followers danced themselves into euphoria, he lay in a garret at the top of the house dying. He died a month later prophesying that he would be resurrected in three days. It was thought that his passing would put an end to the madness. However, it was not to be, as three days after the reverend had been laid to rest the multitude still remained in the village, and the din of singing and chanting continued as they waited for Mason to rise from his coffin.

In desperation Mason's successor, Revd Rushworth, opened up the rector's grave and displayed the corpse to show one and all that their leader was indeed stone dead. Incredibly there were some who still believed that Revd Mason would put in an appearance and they hung around the churchyard for up to sixteen years. Eventually they were dispersed by the army.

16. ST FRANCIS' CHURCH, TERRIERS

The area of Terriers, around a mile and a half outside the centre of High Wycombe, is a curious location. The name isn't mentioned in documents until 1714, and either relates to the name of a family which farmed the area, or derives from people 'tarrying' in the locale before moving on after leaving Wycombe. The absence of any documentary evidence suggests that Terriers may have been part of Kings Wood, a medieval hunting forest. The area was still relatively rural and sparsely populated in the 1930s, which poses the question as to why a grand substantial church was built there.

The church of St Francis of Assisi was built in 1930 from designs by Sir Giles Gilbert Scott, one of the most eminent architects of the twentieth century. His buildings include Liverpool Cathedral and Battersea Power Station. He is also famous for designing Britain's iconic red telephone boxes. He came from a celebrated family of architects, the most famous being his grandfather, Sir George Gilbert Scott, who designed the Victorian Gothic splendour of St Pancras station in London.

The church of St Francis is an example of modern Gothic, and despite being considered one of Scott's finest designs, it is to some degree an impressive, but

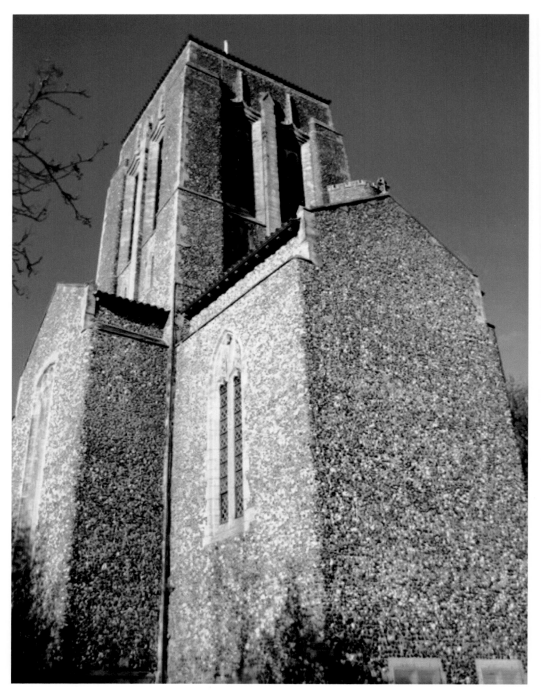

1930s Gothic.

The entrance.

austere building without east or west windows. It has a lofty central tower with tall paired bell openings, concave side arches and what has been described as a severe chancel, transepts, with a blank nave without a clerestory.

One may ask why it is included in this book. It is an important church in as much as it shows that the Gothic style didn't finish with the ending of the Victorian era. Giles Gilbert Scott was noted for blending Gothic with modernism, yet whether or not it works is, of course, a personal preference. Yet we may also look upon the style of St Francis with another view. All architecture reflects its own time – be it Saxon, Norman, or Gothic. The style, of course, tells us something about the age and what has gone and what might be on the horizon. Does Gilbert Scott's severe design hint at the 1930s, what was occurring across Europe and the calamity and hardships the world would soon face?

17. ST PETER AND ST PAUL'S, DINTON

This is a pleasantly located church and village on the edge of the Aylesbury vale with views from the south-facing churchyard to the distant Chiltern escapement. At first glance the building appears to be thirteenth century with a late Gothic (Perpendicular) tower. However, there was a church on this site

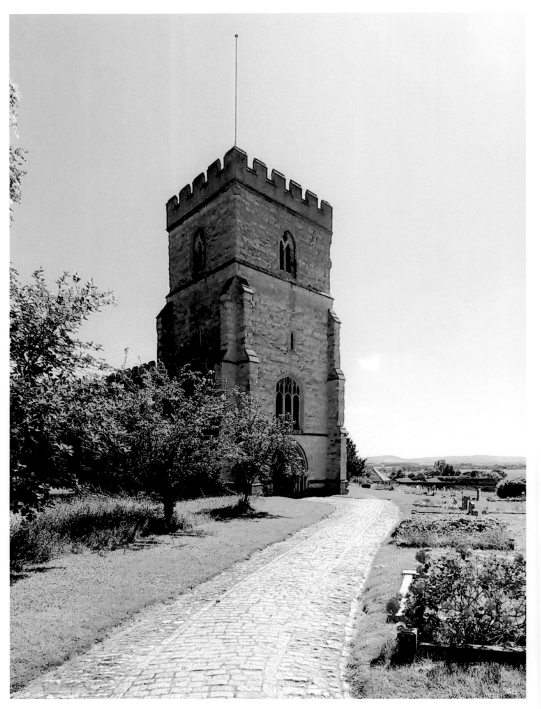

The west tower.

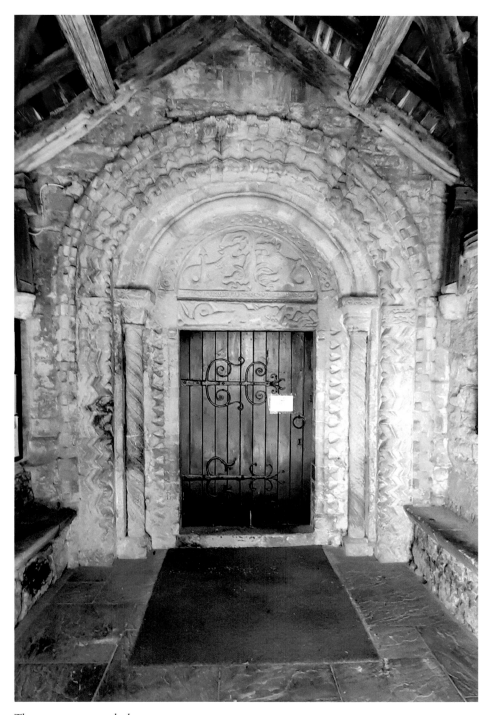

The sumptuous south door.

at least as early as 1140, with the chancel being extended in 1230, and a south aisle and arcade added around 1240. The south porch was added in the late fifteenth century.

The church was much restored in 1868, but still retains its crowning glory: the beautiful Norman south door. The doorway is a superb example of Romanesque sculpture. It is arranged in three orders, each carved with complex designs including a row of hearts, foliage, beading, a bird and a strange beast. Above the doorway is a squared-off lintel, which is carved with a likeness of a winged St Michael and a dragon – a reminder to Dinton churchgoers that Christianity had slain the beast of paganism. Within there is a Jacobean pulpit, Decorated font – which Pevsner believes could be, in part, Norman – an alter table of 1606 and communion rails of 1770, and brasses.

The village of Dinton, the church and the adjacent sixteenth-century manor house are connected with the Mayne family. Sir Simon Mayne was MP for Aylesbury and was one of the men who signed the death warrant of King Charles I. Following the Parliamentary victory at the Battle of Naseby in 1645, he entertained Oliver Cromwell at Dinton Hall, and one wonders if the defeat, trial and execution of King Charles was discussed. Tradition says that John Bigg, a clerk from Dinton, was persuaded to be the monarch's executioner. On a freezing January day in 1649, his axe came slicing down onto the king's neck, the watching crowd omitting such a moan as had never been heard before.

Following the restoration of Charles II in 1660, Simon Mayne was arrested, tried and sentenced to death. He died in the Tower of London in 1661 before his appeal could be heard. The new king established a commission to find those who had executed his father. Many eyewitnesses were questioned and several possible names put forward, yet no firm evidence was forthcoming as to the axe man's identity.

Back in Dinton, John Bigg lived to the respectable age of sixty-seven, and was buried, like his master, in the churchyard.

18. St Peter's, Gayhurst

Gayhurst is a small village in the north of Buckinghamshire on a busy B road between Newport Pagnell and Northampton. The village name is an Old English word meaning 'the wooded hill where the goats are kept'. Indeed one might easily drive through and not give the location a second thought. However, Gayhurst contains one of the best-preserved churches in Bucks. It was the Wrighte family, the then lords of the manor and owners of the adjacent Gayhurst House, who built the present church in 1728. Gayhurst is mentioned in Domesday Book, and it is recorded that a church existed there in the early thirteenth century. In 1724 it was found to be ruinous, and Nathan Wrighte was given permission to demolish and rebuild a new church on the site. However, Wrighte did retain the original medieval crypt.

The building has remained essentially unmodified and is a gem for the church crawler, for its Renaissance design is very much in the style of a Georgian reception hall. It retains all of its original fittings, with oak panelling covering the walls. Within the chancel there is a gilded oak reredos with large panels upon which are

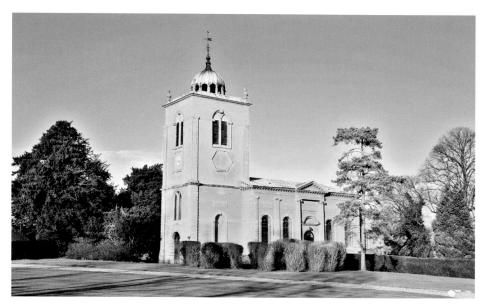

Above: Classical Gayhurst church.

Below: The Wrighte monument.

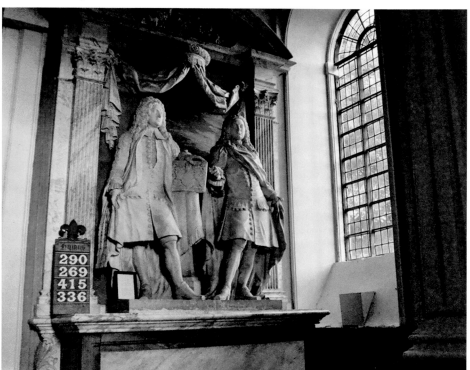

painted texts from the Ten Commandments, the Lord's Prayer and the Creed. The nave is entirely seated with box pews, with a single large pew for the Wrighte family.

The church's crowning glory is the Wrighte monument set against the south-east wall of the nave. It depicts George Wrighte and his father, Nathaniel. The two men stand as they were modelling their Georgian costumes. Sadly they were to both die within four years of one another – Sir Nathan in 1721 and his son in 1725. The monument was probably erected in 1730, and is considered the best sculpture of its type in England.

It is perhaps the historical connections with Gayhurst House which are also intriguing for the visitor to the village. Sir Everard Digby, a previous owner of the house, was one of the conspirators involved in the Gunpowder Plot to blow up King James I and VI in 1604. Even though Digby had been knighted by King James, he otherwise disagreed passionately with the monarch's policies towards his faith as a Catholic. Although the plot was hatched at Ashby St Ledgers in Northamptonshire, the home of its chief protagonist, Robert Catesby, on several occasions the conspirators, including Guy Fawkes, met at Gayhurst.

19. St Bartholomew's, Fingest

Fingest is another beautiful Chilterns location which fulfils all the requirements one looks for in the typical English village. It can be found just a few miles from

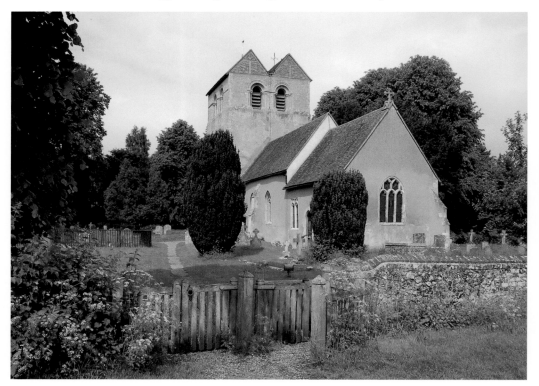

Fingest church with its saddleback tower.

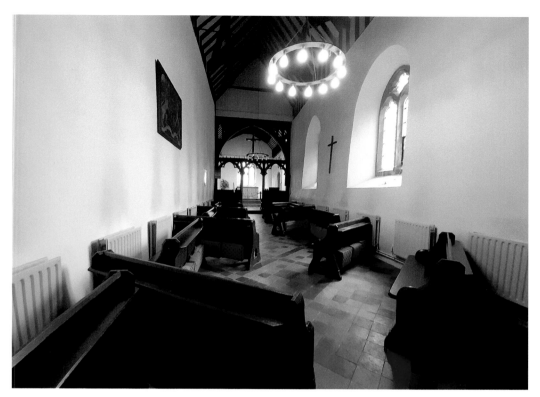

The nave.

Turville (see Turville) sitting in stunning Buckinghamshire scenery. The village name comes from the Old English 'Thinghurst', meaning 'wooded hill where assemblies are made'. In the sixteenth century the name is recorded as 'Thingest' and then 'Fingest'.

The manor of Fingest anciently belonged to the abbey at St Albans in Hertfordshire. In 1163 it was given to the Bishops of Lincoln, and the north side of the church is thought to be the site of their palace. The church of St Bartholomew is a curiosity in that its massive tower dominates the tiny body of the church, and is the one landmark one immediately takes in when you enter the village.

The huge Norman tower is 20 metres high and has walls over a metre thick. It was built in the early twelfth century, and is topped by unusual twin gables – it is believed that only one other similar church tower exists in England. The nave of the church is joined to the tower by a twelfth-century arch, suggesting that the tower was at one time the original nave. Although the church was restored in 1866, it still retains its thirteenth- and fifteenth-century lancet windows. The font is fourteenth century and there are the royal arms of Queen Anne.

The beauty of Fingest lies in its combined charms. There is its stunning, peaceful location, the perfect centre of St Bartholomew's Church, and the eighteenth-century Chequers Inn, its period cottages and a sensibly retained red telephone box. It is

no wonder that the village has been used as a location in the popular *Midsomer Murders* TV crime series. And yet for all its Englishness, in 2013 Fingest was transformed into a village in Normandy for the Hollywood movie *The Monuments Men*. No doubt the Frenchmen who built the church tower would have approved.

20. ST JOHN THE BAPTIST, LITTLE MISSENDEN

A picture-perfect church within a picture-perfect village. Little Missenden is a prize beauty spot just off the A413 Aylesbury to Amersham road. Despite the speeding nearby traffic, the village has managed to retain its peace and quiet, and oozes charm and tranquility sitting in the valley of the River Missbourne and surrounded by perfect Chiltern scenery.

A single street winds its way past the first of its two pubs, the Crown; Little Missenden House; some pretty brick cottages by a tiny green; the Red Lion inn, where the river slides noiselessly through the pub's garden; and on to an impressive Jacobean manor house.

The village's main street continues past the manor house and on to the compact and architecturally interesting church of St John the Baptist, a building well worth spending time to explore.

Architectural historian Sir Nikolaus Pevsner states the church dates from the Norman period, mid-eleventh century. However, the church guide says that the building was established during the late Saxon period, and within there is evidence that the structure dates back to before 1066.

The round arches of the nave arcade are Norman, but above there are the remnants of small windows cut into an earlier wall. The tall proportions of the

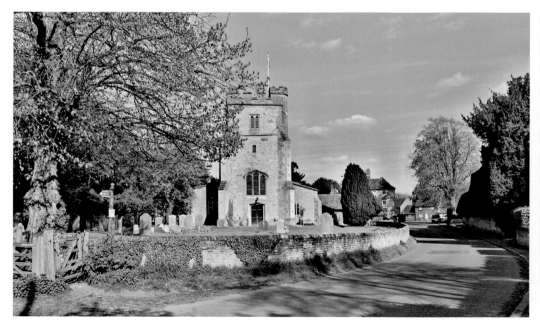

The church from the west.

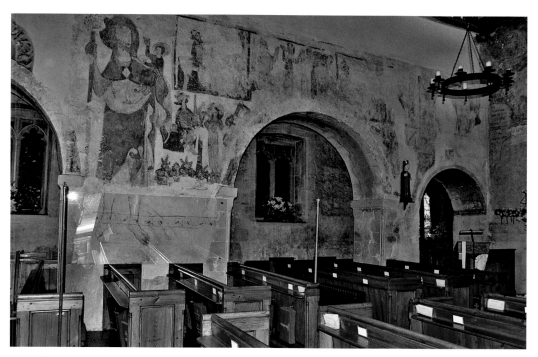

The nave wall paintings.

nave also point to a Saxon date, and it's possible that the church is transitional from Saxon to Norman. The architectural lineage of the church continues in the Early English chancel with three lancet windows, and the Perpendicular, fourteenth-century tower and tower arch.

There are eighteenth-century windows in the south aisle, and also an eighteenth-century dormer window visible on the outside of the nave roof. A curiosity this, as windows positioned as such might lead one to think that it was to illuminate the rood screen and loft. Rood screens were a feature of medieval churches. The word rood is an Anglo-Saxon term for cross, and upon it was a statue of the crucified Christ above the chancel screen. They were abolished following the Reformation, but one can still see the rood beam above the chancel arch to which the cross was attached.

The church also contains a Norman font and fragmentary wall paintings, the finest being a thirteenth-century depiction of St Christopher facing the south door, a reminder to the good people of Missenden that the patron saint of travellers had guided them safely to their church.

21. ST MICHAEL'S, CHENIES

A curious name for a compact, pretty village on the Hertfordshire border. In the thirteenth century it was known as Isenhampstead Chenies to distinguish it from nearby Isenhampstead Latimer, the names of two families who were lords of their respective manors. In the nineteenth century the prefix was dropped.

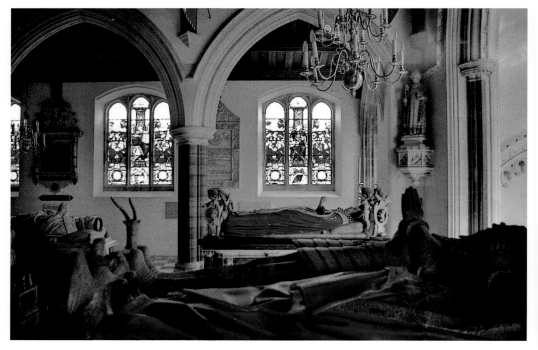

The magnificent Bedford chapel.

It is a place of contrasts. Essentially a Buckinghamshire estate village once owned by the Russell family, who became Earls and later Dukes of Bedford, it consists mainly of nineteenth-century rebuilt cottages, a pleasant green complete with a village water pump and local pub, The Bedford Arms. Yet, its chief glories are from the medieval and Tudor periods.

It would be wrong to mention St Michael's Church without including Chenies Manor House. Thomas Cheyne, who the village is named after, was a shield bearer to King Edward III. It was his descendant, Sir John Cheyne, who built Chenies Manor House in 1460. In 1526 the village and manor passed by marriage to the Russell family. It was John Russell, 1st Earl of Bedford who set about improving the house between 1530 and 1550 as his home and enlarging it to the size and standard needed to house the royal court. Henry VIII is known to have visited the manor several times, with a court and retinue which probably amounted to 1,000 people. In 1534 he attended with Anne Boleyn and Princess Elizabeth.

Chenies' other main attraction is sadly not open to the public, yet it is still possible to glimpse part of it. St Michael's Church, although dating from the fifteenth century, was heavily restored in 1861. Its main point of interest is the Bedford Chapel. It was built in 1556 and contains a fantastic grouping of funerary sculpture covering almost five centuries. They are considered the grandest collection of family monuments outside of Westminster. It is here that the Russells are laid to rest. The chapel is kept locked and the visitor has to be satisfied by

viewing the display of tombs through a glass screen from the nave. It is this private segregation of the chapel from the rest of the church which has allowed the Russell monuments to remain in an astonishing, unspoiled condition – they could have been sculptured and painted yesterday.

22. ST MARY'S, CLIFTON REYNES

An attractively sited, totally embattled church which has been added to and altered over the centuries, St Mary's stands at the end of a long lane, seemingly isolated despite the fact that it is not far from the outskirts of Olney. The church consists of an aisled nave, chancel, north chapel, west tower, and a south porch. St Mary's has Norman origins with a twelfth-century Romanesque tower. However, the top of the tower is fourteenth century. Simon Jenkins in *England's Thousand Best Churches* suggests that the building, due to its tall and narrow nave, may well be Saxon.

The aisles are thirteenth century, and the chancel was rebuilt in the fourteenth century. Around 1360 a north chapel was built, as well as the nave arcades. The nave was heightened with the addition of a clerestory in the fifteenth century. The chancel, in particular, is a good example of fourteenth-century architecture. The north aisle was rebuilt in 1801 and contains large windows with intersecting tracery, an attempt at late Georgian Gothic.

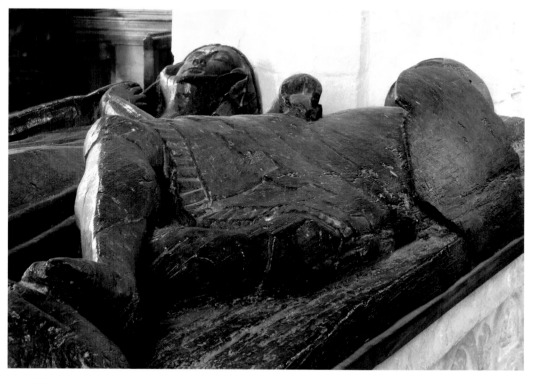

The carved tombs.

The church from the south.

The chief attraction of St Mary's is the Reynes chapel, dedicated to the family who gave the village its name. Within the chapel is a collection of effigies to the Reynes family. They are rare surviving medieval oak carvings. The effigies date to the early fourteenth century, but it is not certain who they represent. It is possible that one is of Sir Ralph and Lady Mabel Reynes. Sir Ralph held Clifton manor in 1303. The detail of the costume is quite wonderful and presents a vivid picture of fourteenth-century style.

There is a second pair of wooden effigies, in a style of costume that suggests they were carved in the early fourteenth century. They are thought to be Sir Thomas Reynes and his wife Joan. Once again, the detail of the carving is remarkable, and the tomb is replete with panels depicting heraldic designs.

Ironically, given the perilous nature of wood, there is an adjacent much-worn stone memorial to a later Reyne, dated to the very late fourteenth century. It is possibly the tomb of the 3rd Thomas Reynes, who died before 1394.

23. HOLY TRINITY, PENN STREET

The Gothic Revival of the 1840s was the Victorians' desire to return the churches of England, and, hopefully by extension, the country, to an imagined medieval idyll. The Industrial Revolution had depleted the countryside and rural towns of

Victorian Gothic.

their populations to work in the grimy industrialised cities. It was thought that the people, now subjected to the hardship of the grinding, smoke-belching factory system, would lose their religion. This, together with the effects of 300 years of Protestantism following the Reformation, where churches had been stripped of their Catholic, awe-inspiring iconography to become little more than preaching boxes, forced movements such as the Camden Society and the Tractarians to reform the church and reintroduce mystery and magic to church services. This could only be achieved in a building which was in the Decorated Gothic style of the early fourteenth century. Holy Trinity is one such church that demonstrates this handsomely.

It sits attractively on the fringe of Penn Wood, and was built in 1849 by the 1st Earl Howe to the design of the architect Benjamin Ferrey. It is a simple cruciform building comprising a nave, south porch, north and south transepts, chancel and a priest's vestry on the north side of the chancel. An octagonal tower rises above the transept crossing, complete with shingle-covered spire, from which the rainwater is thrown by means of eight gargoyles.

The large chancel is reserved for the use of the Howe family and contains two large stalls. On the north wall hangs the banner of Sir William Howe, who fought at the Battle of Bunker Hill (1775) during the American War of Independence, which formerly hung in Westminster Abbey for many years. There are brasses in the chancel to various members of the Curzon family, and one commemoration of King Edward VII which marks the occasion of his visit to Earl Howe, when he attended divine service at Penn Street on 19 January 1902.

Holy Trinity is a good example that the Victorians could, when attempting their own reimagining of the Gothic style, get it right.

24. HOLY TRINITY, BLEDLOW

Those readers who are fans of the TV crime drama *Midsomer Murders* will probably recognise Bledlow village and Holy Trinity Church. In the show the village is Badger's Drift, and it has the distinction of being the location of the very first episode.

Bledlow derives its name from the last resting place of Bledda, an eighth-century Anglo-Saxon chieftain. His burial mound, or hlaw in Old English, is said to be located on the wooded slopes which rise up south-west of the village. However, the name may well mean Bloody Hill, and refers to an undated battle between the Saxons and the Danes.

Holy Trinity Church has Norman origins and dates from the twelfth century, but like many churches has later additions. Aisles were added in 1200 with a west tower in the late thirteenth century. It is largely unaltered with fragments of wall paintings, fine thirteenth-century carvings on the piers and a Norman font of the Aylesbury design. The main entrance through the south porch is early fourteenth century which encases a thirteenth-century door.

The church sits next to an extraordinary feature known as the lyde garden, an exotic water garden planted in a deep ravine east. The churchyard overlooks the gully where water from eight springs emerges. The garden has been beautifully landscaped with walkways, bridges and a small colonnade at the southern end, creating a very peaceful atmosphere. The name lyde probably derives from the Old English hlud, 'loud', meaning 'roaring stream', suggesting a much more forceful flow of water in earlier times. A visit to Holy Trinity is a delight. Sometimes synchronicity can make our visits that much more rewarding if one is lucky. One warm, cloudless, summer's afternoon after my wife and I left the church, we repaired to the pub for a well-deserved pint. As we sat outside in the sunshine two riders clopped past on their way to the bridal path which leads up to the Icknield Way. Down on the village green a cricket match was in full swing. To complete the perfect picture a steam train from the Chinnor and Princes Risborough preserved railway chuffed and

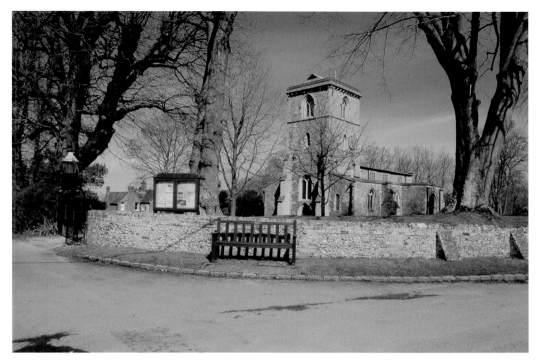

The church from the west.

hooted its way along the line in the valley. It could have been a vista from seventy years ago. My wife and I looked at each other and smiled. It was a moment of blissful serendipity.

25. ALL SAINTS CHURCH, HIGH WYCOMBE

The church of All Saints in the centre of Wycombe has the distinction of being one of the largest town churches in Buckinghamshire, with a spacious and impressive six-bay nave, central crossing, side chapels and a solid west tower, which rises some 30 metres.

There was probably a place of worship on the site as far back as Saxon times, yet the church we see today was founded in the Norman period, and consecrated by St Wulfstan, Bishop of Winchester (1062–95). However, as with most churches in England, it has been altered and added to over the centuries. The architecture we see today is late thirteenth century. The original central crossing tower was pulled down in 1509 and rebuilt at the west end. The upper part of decoration with quatrefoil parapets and pinnacles was added in 1755 and designed by Henry Keen, who, two years later, designed the Guildhall in the High Street.

The church's chief monument was erected in 1754 and stands in the north chapel. It is to Henry Petty, Earl of Sherbourne, who died in 1751. It is a magnificent piece of work and truly worthy of a cathedral. It depicts the earl dressed in the garb of a Roman centurion, with members of his family adorned in togas. Its fashioning

illustrates how the rich and powerful of Wycombe viewed themselves and the Church of England in the eighteenth century.

Although the church is chiefly thirteenth century, the interior is a Victorian restoration of 1873, as is the exterior, which was restored in 1887. Most churches underwent renewal and refashioning in Victorian times following the Gothic Revival.

The Gothic Revival began around 1840, and was the Victorian's desire to return churches to a medieval appearance. If we could return to All Saints in the reign of Henry VIII we would be shocked at the appearance of the interior. It was a riot of colour; it was everywhere, on statues, mouldings, walls, hangings and windows. A giant screen (the rood), topped by a statue of Christ, separated the nave from the chancel. There were numerous altars throughout the church with its own lamp burning. The dim lighting, smell of incense and the coming and going of chanting priests created an atmosphere of mystery and awe.

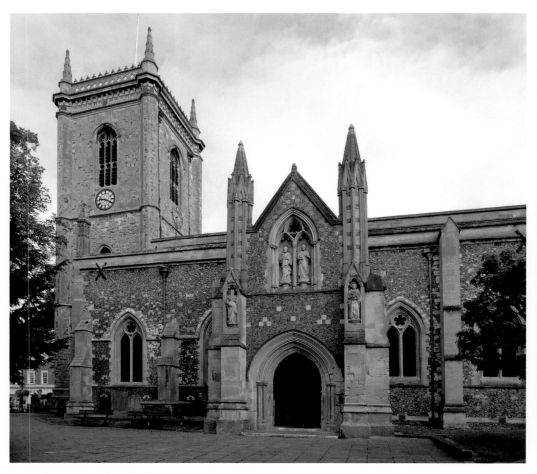

The tower and south door.

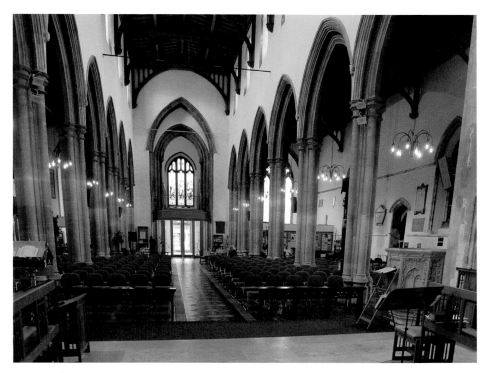

The grand nave.

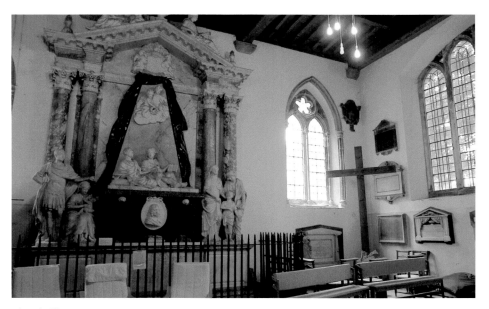

The Shellbourne monument.

Following the Reformation and the establishment of the Protestant Church of England in 1547, during the reign of Edward VI, all superstitious idolatry, popery and iconography was ordered to be removed. The celebration of the sacrament gave way to the sermon. However, by the nineteenth century, the Industrial Revolution had transformed the country into a belching, choking factory. The Victorians looked to the past and the medieval period as a romantic idyll, and restored churches to a pre-sixteenth-century appearance. Nonetheless, we can see this as just another period of All Saints' history.

26. ST MARY THE VIRGIN, LONG CRENDON

Once again for the Buckinghamshire church lover, St Mary's, Long Crendon, is well worth a visit.

There was a church here at least as early as the Norman period, but the building we see today is the result of a complete thirteenth-century rebuilding, when Long Crendon was under the patronage of Notley Abbey. The oldest part is the chancel, which dates to around 1235, while the rest of the structure dates to around 1265. In 1335 the north aisle was widened and a north porch added. The central tower and west wall of the nave were rebuilt in the seventeenth century. In the south aisle

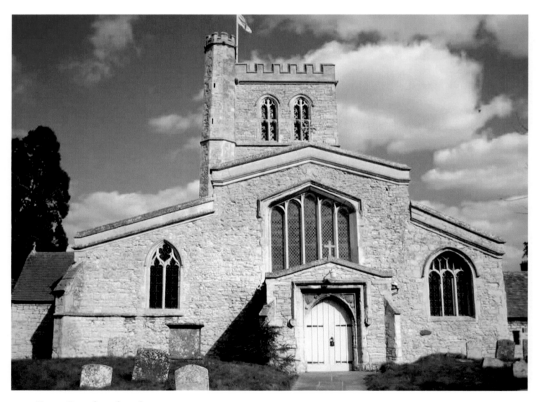

Long Crendon church.

is a finely molded thirteenth-century doorway. Also in the south aisle is a fifteenth-century window and fourteenth-century font, topped by a carved Victorian cover. The font was carved around 1380, with quatrefoil panels on the sides and angel figures at the corners.

St Mary the Virgin also contains a memorial of note. The Sir John Dormer monument in the south transept dates from 1627. The tomb was designed by Nicholas Johnson and is set behind a contemporary iron railing. Dormer's effigy shows him as a knight in full armour, set in a classical recess flanked by Tuscan columns. Every surface of the memorial seems to glitter with gilding, and the effect is quite stunning. Behind the tomb is a blocked fourteenth-century window and in the corner are some reset twelfth-century stones. Also in the transept is a Victorian fireplace. The transept is set off from the tower by a seventeenth-century wooden screen. A Buckinghamshire church gem worth stopping for.

27. ST MARTIN'S, DUNTON

Dunton is a remote village in deepest Bucks halfway between Aylesbury and Buckingham. It is little more than a hamlet with a few cottages, rectory, farm and the church of St Martin. The church is all the better for its isolation, for it is a charming, rustic building in need of restoration of the fabric, yet its simplicity and raggedness is its appeal. It is also a good example for the newcomer to church

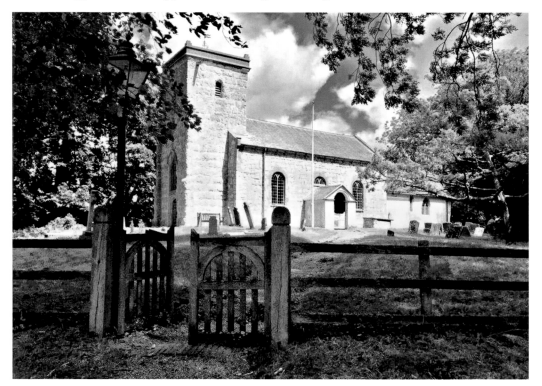

Picturesque Dunton church.

The ghost of a Norman doorway sits beside an eighteenth-century window.

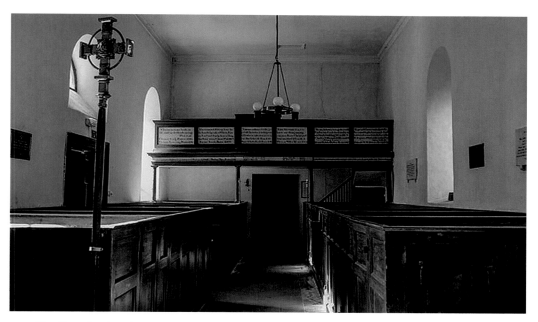

The Georgian interior.

crawling to explore the changing styles of architecture and liturgical requirements which have occurred over the centuries.

As one pushes open the churchyard gate we see a typical building of west tower, nave and chancel. The tower is Perpendicular and can be dated to the late fourteenth or early fifteenth century. Yet, as we explore around the outside of the church we can see that the east side, the chancel, contains three lancet windows, which takes St Martin's back to the thirteenth century. Carry on around to the north of the church and we find a blocked Norman doorway, an indication that the building is of twelfth-century origin.

Indeed the nave is also of this date. However, if we look at the windows of the main body of the church, we notice there is a difference. These date to the eighteenth century, and were installed to keep up with fashionable tastes of the Georgian period when the south wall of the church had to be rebuilt. The south porch was probably also constructed at this time.

As we push open the south door we enter the nave, which still contains its Georgian furnishings of box pews and west gallery. A rare occurrence in England, it is known today as a 'Prayer Book' interior. When the church was first constructed there would not have been seating, just a bare floor possibly covered in straw. The parishioners of Dunton would have participated in the service whilst standing in a dimly lit church. Those too weak or infirm went and sat by the wall, hence the saying 'the weakest go to the wall'.

The eighteenth-century interior of St Martin's demonstrates the changing liturgical requirements of worship in English churches following the Reformation

and the Dissolution of the Monasteries during the Tudor period in the sixteenth century. The interiors of parish churches were stripped of their Catholic idolatry of stained glass, wall paintings and smell of incense, and replaced with more sober Protestant furnishings. Long sermons became prominent in the service and the box pews not only provided comfortable seating, but also protection against the cold and draughts in the winter months.

28. ALL SAINTS, HULCOTT

Located just outside the town of Aylesbury, All Saints is a pleasantly sited small building surrounded by a pretty green away from traffic and other distractions. Here one will find just the church, a manor house, farm and a few cottages. The church dates mainly from the thirteenth century, with a nave, chancel, and aisle. But in its changing architecture we can see how parish churches were almost in a state of constant flux and alteration throughout their history.

The east bay of the south aisle was originally a transept or lady chapel added around 1330. Further changes came in around 1340 when the chancel and chancel arch were rebuilt, making them larger. The west and north windows of the nave date from the fifteenth century. They were replaced to enlarge them, as was often the case. The adjacent porch may well date from the same period. The wooden bell turret could also date from the fifteenth century. It is over the west end of the nave, on a wooden framework supported by four timber posts that reach down to the floor of the nave. In the sixteenth century the transept walls were demolished to enlarge the church by adding a new south aisle almost the complete length of the nave.

All of these alterations and additions to the church were often the ambitious plans of the lord of the manor at the time, who wished to 'show off' his church, or just follow the prevailing changes in architectural styles of the day.

Some of the additions and changes to Hulcott church appear to tie in with changes in the family names of the lords of the manor of Hulcott, with their manor house that stood just to the south of the church, or previously within a moat just to the east.

Benedict Lee was lord of the manor from 1472 to 1535. The Lees were a Bucks family of ancient stock. In the south aisle there is an altar tomb that originally had brasses with heraldry that showed the tomb remembered a member of the Lee family.

The lord of the manor played a vital role in the church's history in Victorian times with the Rothschild family. They are mainly known today as the builders of the magnificent French-style manor house at Waddesdon near Aylesbury. In 1859 Lionel Rothschild became lord of the manor of Hulcott.

There was a succession of three rectors during this important era for Hulcott church. Between 1861 and 1863, the Oxford diocesan architect George Edmund Street was called in to restore All Saints Church. All the roofs were replaced with Street's typically solid structures, and the sturdy stone pulpit is unmistakably Street's work. Unfortunately, as in many other churches restored by the Victorians, the box pews were replaced with ordinary shorter ones.

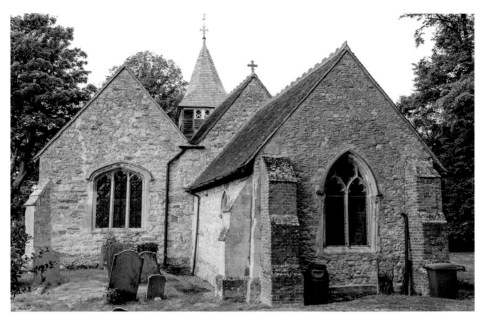

Hulcott church from the east.

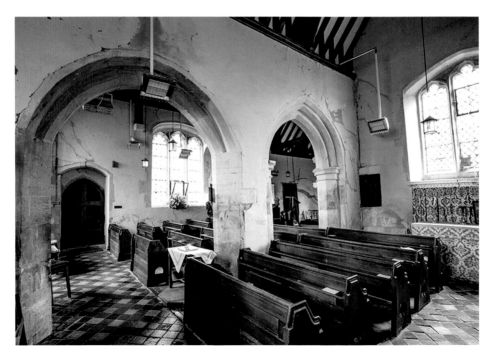

The nave.

29. ST MARY AND ST NICHOLAS', CHETWODE

One of the most important churches in Buckinghamshire, St Mary's stands in a remote corner of north-west Bucks, and was established in 1244 as an Augustinian priory. Despite its chequered history and age, it remains in a remarkable state of preservation. There was already a church at Chetwode before the building of the priory, but none of this remains. What we see today is the surviving nave, north chapel, tower and former chancel of the priory church with its magnificent five-lighted east window. The north and south wall windows of the chancel contain thirteenth-century glass. The chancel also retains its sedilia group (seats for the practising clergy to sit on), one of which has been converted into a doorway.

In 1480 the priory was disbanded, and the priory church became the parish church. The interior is an intriguing and pleasing mix of medieval features with later Elizabethan and seventeenth-century furnishings. The main body of the architecture is superb Early English work, a style which lasted roughly from the late eleventh century to the end of the twelfth century. The north chapel was converted in the seventeenth century into the manor pew, with wooden panelling and a fireplace to keep the squire's family warm through the coldest sermons. There is also a painted wooden triptych dated to 1696, and near the organ is a grave slab from *c*. 1350, carved with a foliated cross.

A visit to Chetwode church is indeed a pleasure. Here one can sit in the peace of the thirteenth-century nave and take time to contemplate the passing of history. I recommend some sandwiches, a glass of wine or flask of tea and at least an hour of silent thought to let it all seep in.

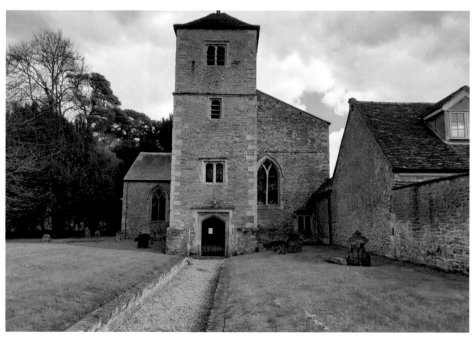

Chetwode church.

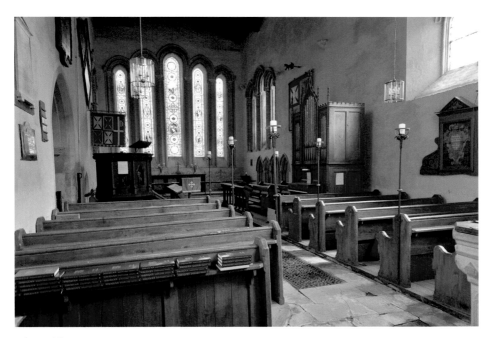

Above: The nave.

Below: Thirteenth-century sedilia and doorway.

30. St Peter and St Paul's, Ellesborough

Ellesborough church stands proudly on a steep knoll between the towns of Wendover and Princes Risborough. As one looks south from the churchyard the beech-covered landscape dips and rises across to the dominating Beacon Hill with its grassy mound and lone tree, iconic amongst the Chiltern Hills when viewed from within the Vale of Aylesbury. It is also the site of Cymbelines Mount, which is referred to in Shakespeare's play *Cymberline*. In reality, the reference is to British king Cunobelinus, leader of the Catuvellauni people, who led his tribe against the Roman invasion of the British Isles. This is ramblers countryside, and many ancient tracks and pathways criss-cross the area. Iron Age and Roman finds have been discovered leading to the tradition that the Catuvellauni hero Caratacus, who fought many battles against the legions, was born here. Looking north, the churchyard slopes precociously down through the trees and tumbling gravestones to give views out over the Aylesbury Vale.

Although constructed in the late fourteenth century, the building is very much a drastic Victorian restoration of 1854 and 1871. However, that is not to say that in such an ancient area of Bucks a far older place of worship once stood on the site. The church has a tall south-west tower with a high stair turret built of flint. Within is a south arcade of four tall bays and a handsome alabaster monument to Bridget Croke (d. 1638). She was the last

Imposing Ellesborough church.

of the Hawtry family, who were owners of nearby Chequers Court. Today, Chequers is the country home of the British Prime Minister, and St Peter and St Paul's Church has become known as the Premier's church. Margaret Thatcher came to pray at Ellesborough church, finding comfort there during the Falklands War.

The church is also known for having a resident ghost. Over the years the apparition of a tall man in medieval garb has been seen to glide towards the memorial commemorating the Hawtry family and disappear within.

31. St Nicholas' Old Church, Taplow

In a previous book I wrote on the architecture of High Wycombe, I chose to include a structure which was no longer standing. The Roman villa which stood on the Rye, a grassy open space just outside the centre of the town, dated from the second century AD. It was the largest of its kind in Buckinghamshire consisting of a bathhouse, stables and living accommodation for a large family. Following the departure of the legions in the fifth century the villa was abandoned and inevitably fell into ruin. Apart from its mosaic floors, which were discovered by archaeologists in the 1930s, the building completely disappeared from memory. Despite no longer standing, I included it in the buildings of High Wycombe because it was an integral part of the town's architectural history and heritage;

The Saxon burial mound.

Eighteenth- and nineteenth-century tombs in the old churchyard.

likewise with the vanished church of St Nicholas at Taplow and its importance to the architectural and religious history of Buckinghamshire.

Taplow is a small village close to the River Thames, near Maidenhead and on the county boundary with Berkshire. It takes its name from a seventh-century burial mound in the grounds of Taplow Court. A neo-Tudor mansion was built in 1885.

Taeppas Hlaw has come down to us today as Taplow. Hlaw was the Saxon word for mound, which would eventually come to mean hill. It was the last resting place of an Anglo-Saxon chieftain who may have had royal links with the Saxon monarchies of Kent and East Anglia.

The mound was excavated in 1883 and found to contain a magnificent treasure hoard, which included gold, silver, weapons, drinking horns, glasses, a harp and a bronze bowl imported from Egypt. It seemed to be in no doubt that Taeppa was a pagan, and perhaps the burial location was deliberately chosen as the whole site is surrounded by an Iron Age fortification which dated back almost a thousand years before the chieftain was laid in his tumulus, and may have been a centre of worship. It is all the more intriguing then to discover that at the same time as Taeppa's burial, a Christian church was built only yards from the mound.

It is possible that Taeppa was an on and off Christian, and was shrewd enough to have a foot in both camps. It was at a time in Anglo-Saxon history when many pagans were being converted to Christianity. Just yards from the mound is Bapsey pond, a holy well where St Birinus, who was the first bishop of Dorchester, baptised many Saxons as Christians. The source of the pond comes from the old churchyard where the mound is located, so it is possible that this is the reason the Saxon church was constructed there. We know nothing of the church's design, only that it was either enlarged in the fourteenth century or completely rebuilt.

The church and churchyard continued to be used up until the discovery of the burial mound treasure in 1883, as can be seen by the remaining grave slabs and tabletop tombs. Two years later the church was demolished and a new place of worship was built within Taplow village where one can see brasses from the old church. Perhaps the discovery of a pagan grave so close to a Christian church was too much for Victorian Church of England sensibilities. One wonders what they might have thought of the nearby Taplow court house, which was once owned by The Beatles' George Harrison, and is now the headquarters of the Buddhist religion in Britain.

32. St Lawrence's, Broughton

The churches that underwent restoration in the nineteenth century rarely came through unscathed. Of course, there were those buildings which had stood uncared for for centuries that were indeed in need of some TLC and part rebuilding. Yet, the Victorians' zealousness for the style of the Middle Ages often saw eighteenth-century woodwork removed and the interior plaster of the walls scraped back to reveal the bare stone, usually resulting in disaster. However, not so at Broughton; if it was not for the restoration in 1864, the church's crowning glory might not have been revealed.

St Lawrence's Church dates from the early fourteenth century, but with a fifteenth-century west tower. It is a simple grey building sadly overwhelmed by the urban sprawl of Milton Keynes. However, the church's chief delight is a series of wall paintings that were buried beneath layers of wall covering for centuries until they were revealed during a Victorian restoration.

The paintings cover most of the north and south walls and depict a variety of themes, including St George slaying the dragon, a doom (Last Judgement), a Pieta (Mary with the dead body of Jesus), and various figures of saints.

Some of the paintings were restored, but generally by a restrained hand that did not detract from their original brilliance. The depiction of St George and the dragon takes up much of the south wall. The painting is finely detailed and dates from around 1470. At some point in the church's history the roof was lowered, with the unfortunate effect that St George's head and shoulders were lopped off.

Another of the paintings shows a Warning to Swearers, a fascinating composition with a central Pieta figure. Around the Pieta are clustered nine figures of fashionably dressed men, each holding what appears to be a part of the body.

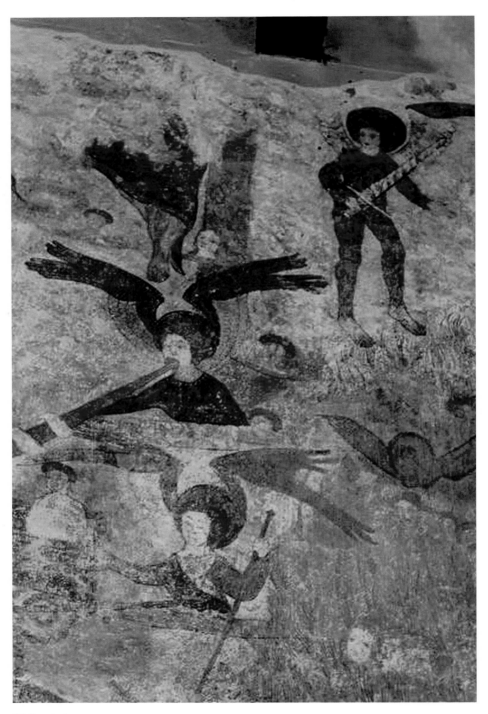

Wall paintings.

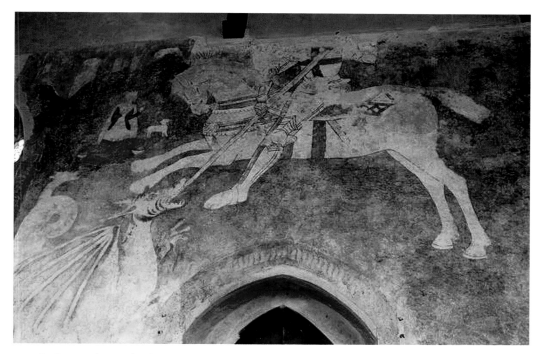

St George slaying the dragon.

Whether or not the image is a satirical jest or a genuine admonition, it would appear to be a warning to those medieval people who swore oaths by parts of Christ's body. Two of the young men are playing at backgammon, so, presumably, the painting is meant to warn against the evils of gaming, as well as swearing.

The wall paintings at Broughton remind us that the morals and lifestyle of the medieval peasant were still guided and controlled by the pictures they saw in their church.

33. ST MARY'S, NORTH MARSTON

One of Buckinghamshire's best churches, St Mary's stands on a little mound above the village. Not only is it known for its architecture, but also two curious historical associations. It is a battlemented church which originally dates from the twelfth century, but has been altered and changed over the centuries. The west tower, north arcade and north aisle are thirteenth century. The south aisle is part fourteenth and fifteenth century. The chancel is Perpendicular Gothic.

From its humble beginnings in the early twelfth century, the church became immensely popular and wealthy as the third most popular place of pilgrimage in England, which was visited twice by King Henry VIII. Its popularity stemmed from its rector between 1282 and 1314, John Schorne, who is alleged to have discovered a spring during a period of great drought by striking the ground with his staff. The spring water became a holy well and the water was claimed to have

Above: The nave.

Below: Squints in the chancel arch.

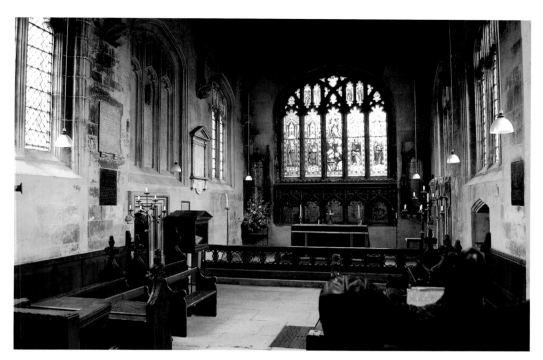

Above: The chancel.

Below: North Marston exterior.

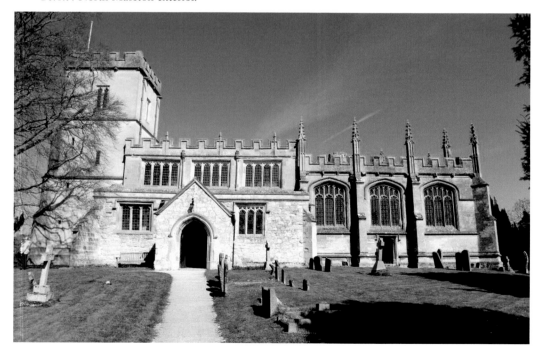

great healing powers for many conditions. The income from pilgrims' votive offerings helped to pay for the enlargement of the church and its adornment with a considerable number of stone carvings, inside and out. It also left the legacy of a stone-built 'watching chamber' to guard the shrine, and a small boot shrine where gout sufferers could place an afflicted foot for a cure from this painful condition.

Although he is regarded as a saint, he was never canonised. Schorne was also said to have cast the devil into a boot, and many pictures depict him holding a boot with the devil inside. It is from this that the origins of the jack-in-the-box derive.

The number of poor and wealthy pilgrims that made the journey to North Marston and left their offerings to the saint was not lost on the Canons of Windsor, who saw what good business the Buckinghamshire church was doing and thought they might also have a share. In 1478, with much-needed funds for the completion of St George's Chapel in Windsor Castle, Schorne's remains were taken from North Marston and reburied in the chapel in the hope that the pilgrims would follow and offer up their riches. Looking at the chapel today, it would appear that the transfer of the saint's relics paid dividends.

But St Mary's need not have worried about the loss of its potential source of income, for some 400 years later another benefactor would arrive to give North Marston 'some' of his not-so-hard-earned cash.

John Neild, born in 1780 in St James Street in London, was the son of James Neild, a sheriff of Buckinghamshire and a noted philanthropist, who liberally gave his time and money in the service of the community. Not so his son. The younger Neild was educated at Eton and Cambridge where he studied law. He was called to the bar and it seemed he would pursue a career in the legal profession.

However, in 1814, at the age of thirty-four, he inherited his father's estates worth £250,000, and all thoughts of becoming a barrister were abandoned for the more satisfying occupation of increasing and maintaining his wealth by unscrupulous, uncharitable, or miserly means. It is possible that Dickens based the character of Ebenezer Scrooge on Neild. He lived in a large house in Chelsea, but it was so meanly furnished that for some time he chose to sleep on the floor of his bedroom rather than in a bed. He held property in Buckinghamshire, but preferred to walk from his London home to his estates to collect the rents from his tenants rather than pay the coach fare. He employed a housekeeper that he paid a pittance, which was reduced even further when he was away from home as he calculated that she then did not do the same amount of work.

Why John Neild became a professed miser and seemingly isolated human being is unknown. He never married, and while at North Marston, in 1828 he attempted suicide by cutting his throat. His life was only saved by the prompt attention of his tenant's wife.

Owning property in North Marston, it was his duty to keep the church in a good state of repair. This he did, but reluctantly so. The roof of the church was in desperate need of renewal, but instead of using lead, Neild went for the cheaper option of calico, saying 'it would see him out'. He remained on the roof all day long to ensure the workmen completed the job.

Even though he had amassed so much money he only once felt the pang of philanthropy and donated £5 to the building of a school and a whole pound to the Sunday school at North Marston.

He died at No. 5 Cheyne Walk, Chelsea, on 30 August 1852, at the age of seventy-two, unloved and unmourned, and was buried in the chancel of North Marston church. His tenants attended the funeral but they came to watch, not grieve. One villager was heard to remark that if Neild had know how much it cost to bring his body from London to be buried in Marston churchyard he would have come down here to die.

Bizarrely, after a lifetime of miserliness, he left the whole of his property, estimated at £500,000, to Queen Victoria, begging Her Majesty's most gracious acceptance. In 1855 Queen Victoria restored the chancel of North Marston church and inserted a window to Neild's memory. And then, with Neild's bequest, the monarch went off to build Balmoral Castle.

34. ST MARY'S, EDLESBOROUGH

One of the most spectacularly sited churches in Buckinghamshire, St Mary's, Edlesborough stands proud of an isolated hillock looking out over the Vale of Aylesbury. Here one can see glorious views over Bucks and into deepest Bedfordshire. The church is battlemented and dates from the thirteenth century with an early fourteenth-century west tower. The north chapel was built between 1342 and 1350, but was enlarged and remodelled in the fifteenth century. Most

Champing in the church.

of the windows are Perpendicular Gothic (mid- to late fourteenth century), save for the east window, which is from 1290. The north doorway is from around the same date.

The church contains the best fittings in Bucks and is known for its medieval woodwork, which includes the chancel and nave roofs, choir desks and stalls, with misericords and a rare complete carved rood screen. The pulpit has an extravagant four-tier tester, and there are medieval floor tiles still in place. The lectern is made from wood rescued from the medieval spire when it was hit by lightning and burned in 1828. There are several medieval brasses in the chancel, including one to Sir John Swynshide, who died in 1390. The north transept is the Rufford chapel, with numerous memorials to members of the Rufford family.

With such a beautiful and interesting church, it is sad and puzzling to learn that St Mary's is no longer used for regular worship. However, in recent years the church has taken on a new role for the curious pastime of champing.

Champing is the name given to camping overnight in a church. One wonders what our medieval ancestors would have thought of such a practice, and not least the eighteenth- and nineteenth-century Romantics who viewed churches as places of mystery and the supernatural and to be avoided after dark. Also we might think that spending the night in a damp and cold centuries-old building is not the height of opulence. Yet the church becomes, for its champers, a unique ancient hotel for their night's stay with comfortable beds, heating and little luxuries to make the stay over all that more fun. Perhaps in its own way, champing has become a new form of spiritual fulfilment.

35. St Nicholas', Ickford

Ickford sits on the border between Buckinghamshire and Oxfordshire, and is a quiet place of thatched and timber cottages in lush meadows by the Thame. The River Thame separates the two counties, and one has the pleasure of traversing a narrow, seventeenth-century bridge over the river to arrive in Oxon.

The church of Saint Nicholas dates from the late twelfth or early thirteenth century. The nave was built in around AD 1210, with a porch in the middle of the south side. The narrow three-bay north and south aisles were added in around 1230. The north aisle has Norman and Early English Gothic thirteenth-century lancet windows.

The chancel has two thirteenth-century lancet windows in its north wall. Near the westernmost of these windows is a rectangular recess that may have been a squint (a small splayed opening in a wall near the chancel giving worshippers a view of the alter).

In its south wall are another lancet window and a thirteenth-century doorway. The Decorated Gothic east window is fourteenth century. The south wall of the chancel has at its east end a window from around 1350 that is said to have been brought from another church. The saddleback west tower is Norman, but the upper stages were remodelled in the fourteenth century.

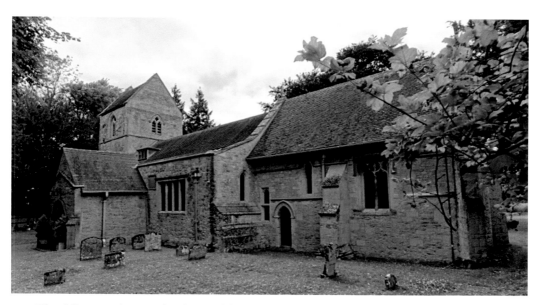

The different architectural styles at Ickford.

In the nave some of the seats are sixteenth century and there is a west gallery fronted with seventeenth-century panelling. The pulpit and its tester are also seventeenth century. The church was restored in 1856, 1875 and 1907, but sensitively so.

The church contains some fine monuments and seventeenth-century woodwork. From 1636 until 1660, the rector of Ickford was Gilbert Sheldon. He became Archbishop of Canterbury and during the turbulent times of the English Civil War he was a trusted servant and advisor to King Charles I. Under the Commonwealth and Protectorate of Cromwell he helped guide and preserve the faithful remnant of loyalists. At the Restoration of the Church and King in 1660, Sheldon was the dominant figure in ecclesiastical affairs, ensuring the Church of England's place in national life, which remained largely unchanged until the twentieth century. It was mostly through the insistence of Sheldon that Christopher Wren was commissioned to design St Paul's Cathedral after the Great Fire of London. Wren had previously designed the theatre in Oxford which Sheldon gave to the university and which bears his name.

36. ST MARY'S, DRAYTON BEAUCHAMP

St Mary's is an isolated but pretty village and church close to the Hertfordshire border. However to get there one must first negotiate the busy intersection for the A41, which runs between Aylesbury and London. As one exits the roundabout a road leads towards Tring, and an almost easily missed road sign points the way to Drayton. One immediately enters another environment of quiet sunken lanes as the route dips and weaves its way between high-banked hedges and pretty cottages. The road crosses over a canal by way of a humpback bridge and it seems as if the hurly-burly of the dual carriageway is far distant.

Fine Perpendicular at Drayton.

St Mary's, with its adjacent nineteenth-century rectory, sits alone up a gated road across sheep-grazing meadows and is viewed against a backdrop of beechwoods. The church is embattled throughout, and at first glance looks to be a late Gothic, Perpendicular building. All the windows are late Perpendicular. However, the body of the church dates from the late thirteenth and fourteenth centuries. Within is a grand eighteenth-century monument on the north wall to Viscount Newhaven and his second wife. The east end contains a fine window depicting a group of ten apostles dating from the late fifteenth century.

In the chancel are two almost full-size brasses from the late fourteenth century of the Cheyne family, who were lords of the manor until 1752. One of the brasses is of Thomas Cheyne, shield bearer to King Edward III.

On the north side of the church next to the graveyard is part of a raised bank known as Grim's Ditch. It is thought to be either an Iron Age or Saxon structure. The bank runs across parts of Oxfordshire, Buckinghamshire and into

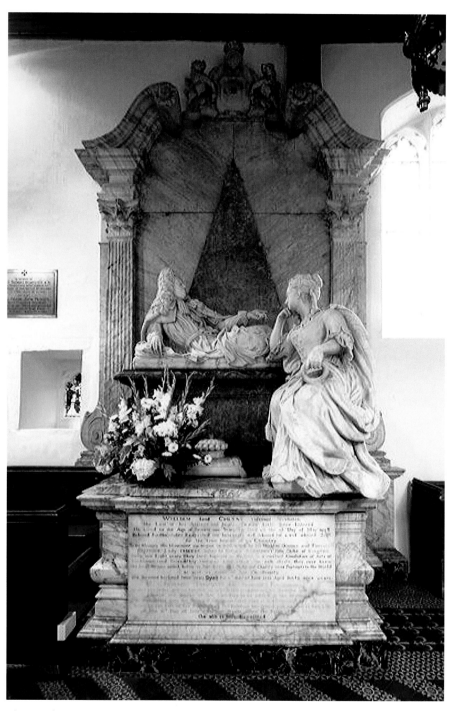

The Newhaven monument.

Hertfordshire. Such is the mysterious purpose of the ditch that it was assumed that it had been constructed by the Devil.

37. ST MARY'S CHURCH, PITSTONE

One of Buckinghamshire's hidden gems containing many excellent features, sadly the church is no longer used for regular worship, and is usually closed, but there is probably a keyholder nearby. If the keyholder cannot be located, St Mary's is open to the public on certain days throughout the year. Happily, the church is in the care of the Churches Conservation Trust.

The church dates from the thirteenth century and is set in an attractive location on the slope of the Chiltern escarpment, directly beside the long-distance footpath known as the Icknield Way. It comprises a nave, north aisle, chancel, north chancel aisle, vestry, south porch, and west tower. Curiously the chancel is aligned at a distinct angle to the main body of the nave, making a noticeable dogleg to the north.

Within is some excellent early medieval carving on the column capitals of the nave, and a Norman font rescued from an earlier church on the site. The font is carved as a fluted circular bowl on a tapering base and probably dates to around 1190. It is one of a number of fonts known as the 'Aylesbury style' after the one in St Mary's Church in Aylesbury.

The chancel floor has quite a few medieval tiles, assembled here from other parts of the church. The tiles depict a variety of heraldic symbols and allegorical signs. There is a wealth of Elizabethan and Jacobean woodwork throughout the church, including the early seventeenth-century pulpit with carved and panelled sides. Look for the beautifully carved fifteenth-century piscina, decorated with the head of a Green Man in the pediment over the bowl.

Other interior features include an interesting brass to Lady Neyrnut, wife of a local nobleman, who died in 1324. It is one of the oldest and smallest memorial brasses to a woman in England. Art historian Sir Nikolaus Pevsner thought it to be the earliest brass in Buckinghamshire.

Over the chancel arch is an indication of how the liturgical priorities of the church had changed by the middle of the eighteenth century, for it depicts the royal coat of arms to George II, set between painted texts of the Lord's Prayer, the Creed, and the Ten Commandments. Under the coat of arms is an inscription reading 'Richard Sear and Bartholomew Adams Church Wardens, 173-'. According to records, the date was likely 1733. It seems very likely that the biblical texts were painted over earlier medieval wall paintings.

In the east wall of the nave is a small squint, or hagioscope, made to allow people in the south side of the nave to see what was happening at the altar during church services. The word is Greek, meaning 'to see the holiness'.

The altar is a seventeenth-century communion table, and it is set off by communion rails set on wonderfully slender twisted balusters of the same date. One of the interesting features within the church is a series of medieval encaustic tiles in the chancel and at the foot of the altar table. The tiles were made at Penn in the fourteenth century. The Penn tile industry supplied many churches in Buckinghamshire and the surrounding counties but very few are still in place like

The west tower.

Eighteenth-century box pews.

the ones at Pitstone. One fascinating tile depicts a grotesque demon with a circular 'target' on his chest. Others show fleur de lys, birds, strange beasts, and geometric patterns.

St Mary's also contains a copy of an extraordinary medieval relic: an enamelled map of the Pitstone area. The map was probably the work of a monk from Ashridge Priory, made to celebrate the building of the first stone church here over 900 years ago. According to tradition, the map was one of several copies made to be distributed to wealthy men in the Pitstone area as a way of encouraging them to donate money to build the new church.

38. ST MARY'S CHURCH, HAMBLEDEN

Hambleden is one of the most attractive locations for a church in Buckinghamshire. The village sits perfectly placed 4 miles west of Marlow in a valley of the Chilterns whose beech-clad hills seem to break like waves down the surrounding slopes. The core of the village is around a small triangular green, with the church of St Mary on the north side. The name Hambleden is Anglo-Saxon in origin, and means 'crooked or irregularly shaped hill'. It was recorded in 1015 as 'Hamelan dene', and in 1218 was the birthplace of St Thomas Cantilupe, the Lord Chancellor of England and Bishop of Hereford. He was canonised by Pope John XXII in 1320 and was the last Englishman to be made a saint before the Reformation. The Saxon font in which he was baptised can still be seen in the nave.

The village church of St Mary is originally twelfth century but was much altered in the thirteenth and fourteenth centuries. The central tower collapsed in 1703 and was rebuilt in 1721. It was then raised and altered in 1882. The chancel aisles and vestry were added in 1859, with further restorations in the late nineteenth century making the church an almost Victorian building. Nonetheless it does contain a few monuments dating from the sixteenth and seventeenth centuries, in particular the fine 1633 memorial to Sir Cope d'Oyley. In the south transept is a sixteenth-century carved wooden panel, which has been incorporated into an altar. It is known as the Wolsey Altar as it includes the arms of Cardinal Wolsey and Bishop Fox. In the churchyard to the north side of the church is the domed Kenrick Mausoleum erected by Clayton Kenrick in memory of his father and sister.

Many of the cottages and houses are of brick and flint, and so regular in style they might almost have been built in one decade. In fact they date from the seventeenth to the twentieth century. The Elizabethan manor house opposite the church was built in 1603 for Emanuel, 11th Baron Scrope, who became Earl of Sunderland. King Charles I stayed there overnight in 1646 while fleeing from Oxford.

St Mary's is also a good example of a church containing a piece of ignominious British history. The manor house is also the birthplace, in 1797, and former home of Lord Cardigan, who led the disastrous Charge of the Light Brigade during the Crimean War in 1854. The sea chest he took to the ill-fated Russian campaign can still be seen in the church.

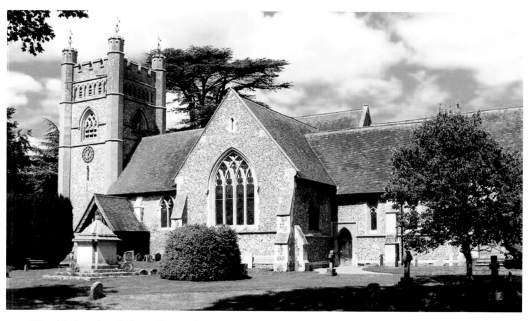

Hambleden church from the south.

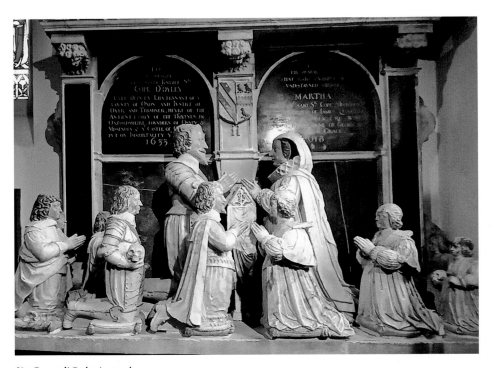

Sir Cope d'Oyley's tomb.

Hambleden church from the north.

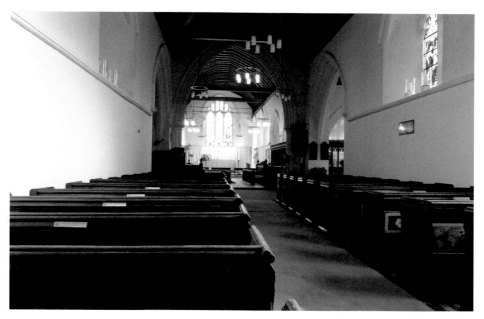

The nave.

The Saxon font.

Above: The chancel.

Below: South transept.

North transept.

About the Author

Eddie Brazil was born in Dublin in 1956 and later raised in South East London. He is a writer, photographer and paranormal investigator. He is co-author, with Paul Adams and Peter Underwood, of *The Borley Rectory Companion* and *Shadows in the Nave: A Guide to the Haunted Churches of England*. In 2012, with Paul Adams, he wrote *Extreme Hauntings: Britain's Most Terrifying Ghosts*, and in 2013 he published *Haunted High Wycombe*. He has also written on the *Bloody History of Buckinghamshire*. He has recently completed *Haunted Camberwell and Peckham*, which he hopes to publish this year.

He is also a guitarist, and in 1983 wrote the theme music to the British comedy movie *Expresso Splasho*, which featured Gary Oldman and Daniel Peacock. Eddie lives with his wife in High Wycombe, Buckinghamshire.